EMBROIDERED
FLOWERS

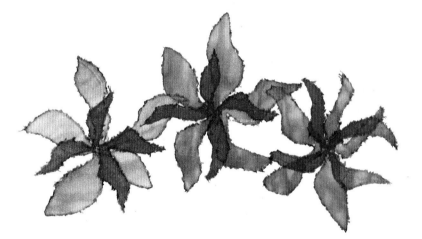

EMBROIDERED FLOWERS

PAMELA WATTS

B. T. BATSFORD LTD., LONDON

Acknowledgements

My thanks to friends, colleagues and students who have generously allowed their embroideries to be included in the book, with particular gratitude to Marion Brookes, Marion Glover, Evelyn Jennings and Margaret Jones. My sincere thanks to Sheila Paine for allowing part of her wonderful collection of foreign embroideries to be illustrated and thanks to David Partridge for photographing them. I am grateful to *New Home* for the loan of a sewing machine, to *Freudenberg Nonwovens Ltd* for Vilene Bondaweb, to *Blue Cat Toy Company* for rubber stamps and to *Madeira Threads (UK) Ltd* for machine embroidery threads.

Lastly my admiration and thanks to Keith Torry for his truly inspirational photography, to Garry Mouat for visualizing the book and my special thanks to my editor, Roz Dace, for her endless support and enthusiasm.

The embroidery, drawings and diagrams are the work of the author unless otherwise credited.

Text and designs © Pamela Watts
Photographs © BT Batsford Ltd

First published 1995 by

B. T. Batsford Ltd
9 Blenheim Court
Brewery Road
London N7 9NT
A member of the Chrysalis Group plc

Reissued in Paperback 1997
Reprinted 1997, 2000

A catalogue record for this book is available from the British Library.

ISBN 0 7134 81617

Designed by Peter Higgins
Printed in Hong Kong

Contents

Introduction

Try, if you can, to imagine a world without flowers. Whether or not we notice them consciously, they are all around us, enriching our lives with colour and beauty. We see a field of poppies on a summer's day, cow parsley turning the hedgerows into lace-like borders and the poor buddleia growing, against all odds, straight out of high brick walls approaching London's railway stations. We treasure memories of bluebell woods and orchards of apple blossom with the promise of autumn fruits. Flowers are given to celebrate, to commiserate and as tokens of friendship and love.

Gardeners (and many embroiderers are gardeners too) talk with passion and pride about their favourite flowers, caring for and tending the plants with a dedication that non-gardeners find bemusing. The first sight of a little red bud on a newly planted paeony holds such promise, waiting and watching day by day for it to fatten and open into the most flamboyant of flowers. I have grown a strelitzia from seed and have cared for this ordinary-looking plant in my greenhouse for four years. One day it will produce the magnificent bird-of-paradise flower – or will it?

This fascination with the diversity of flowers has occupied artists and designers throughout history and in all corners of the world. Embroiderers are fortunate to have the fabrics, threads, paints and techniques to capture the delicacy, colour and beauty of flowers to perfection.

This book is for every embroiderer who seeks to express a love of flowers in his or her own personal way. I have tried to include a wide variety of styles of design, from the realistic to the abstract, and as many techniques as possible. The aim throughout has been to inspire but not to intimidate. To this end, very simple ideas are included as well as large and ambitious embroideries worked by my talented friends and colleagues.

Finally, look at flowers, touch and smell them, draw them and photograph them. The various stages of a flower's life never cease to amaze us. The bud, the full flower, the dying and decay, and finally the seed pods – proving that nature intends to do it all again next year. This is one of the reasons for our fascination.

Achilleas
Cretan stitch, seeding and French knots on painted calico using perlé and stranded cottons with added beads. Three applied small panels of Italian and trapunto-quilted shadow work with fragments of space-dyed muslin and textured threads
Marion Brookes

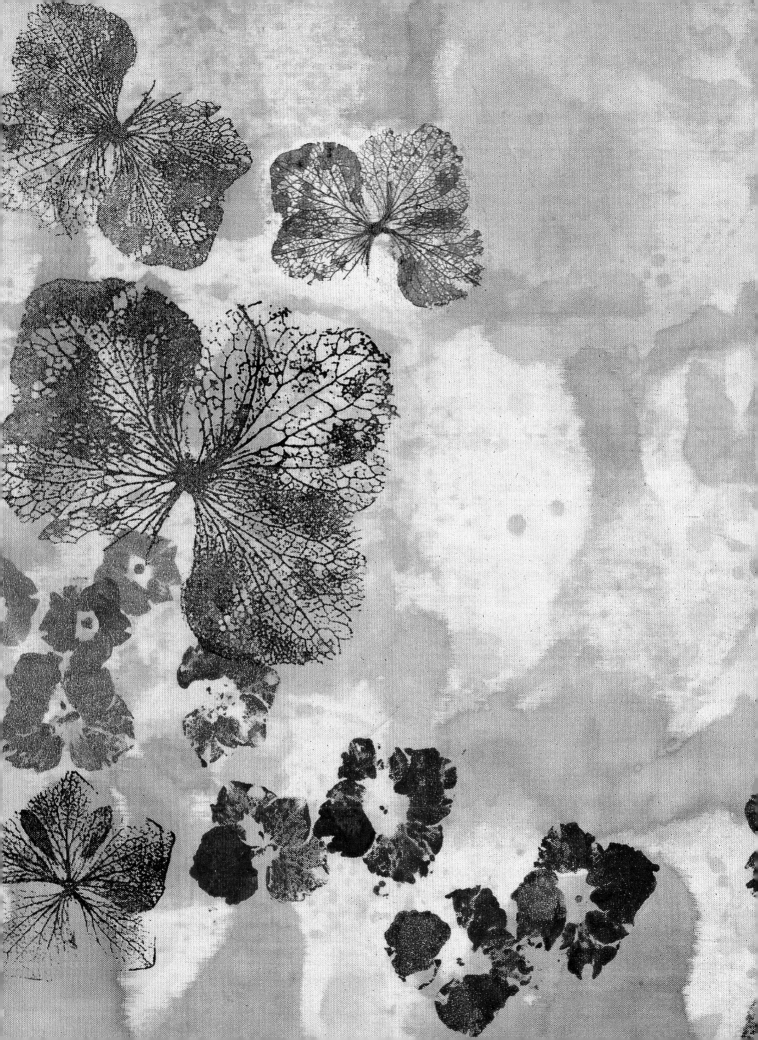

Using *Flowers*

Using Flowers

Flowers are the inspiration and the design source throughout the book but, in this first chapter, ideas are shown for using the real flower itself within the embroidery. Whether trapped, sandwiched, rolled, pulped or applied to a fabric, there is a special excitement in working with the real thing. Perhaps the attraction is the unpredictability of nature and the subtle variations of every flower and petal.

A vast garden of flowers is not necessary, just a few blooms from a pot plant, window box or tub will do. What better way of preserving the remnants of a flower arrangement, a single red rose or an orchid from a bouquet than to capture it on fabric?

Choosing the flowers

It is important to choose the right sort of flower for the first technique of applying petals to fabric. They will be sandwiched between two layers of Vilene Bondaweb, a fusible adhesive mesh, onto a fabric background. As all flowers and the conditions in which they are growing vary, be prepared for the unexpected to happen and accept this as part of the fun! The main requirement for the technique is that the flower should be flat or, as in most cases, that the individual petals can be separated. Although a daisy or a daffodil may look appealing, think about the individual petal shape when it is removed. Some large exotic flowers also have distinctly uninteresting petal shapes. Choose flowers with thin, almost papery petals. I have tried all the following with great success: dianthus, hardy geraniums, roses, hydrangeas, sweet peas, alstroemerias, poppies, pansies, impatiens and clematis. You will have success with many others too. Sometimes, however, a complete failure occurs. I admit to buying a primula obconica from a garden centre with the express purpose of using the delightful deep pink flowers on a shot blue silk. Having taken off all the flowers and applied them to the fabric, they became totally transparent and invisible.

I also forgot, in my excitement, that I am allergic to the sap of this primula, so I ended up with a nasty rash as well! Bear this salutary tale in mind and wear thin rubber protective gloves when you are handling irritant plants.

Applied flowers

Separate the petals from the flower. If they are of a curly variety, leave them spread out on kitchen paper for a few hours until they feel limp. Take a medium-weight silk, calico or cotton fabric. Cut two pieces of Vilene Bondaweb to the exact size of the fabric to be used. Bondaweb is available in small packets or by the metre from most craft shops, department stores and specialist embroidery suppliers. Peel away the backing paper from one of the pieces and lay the adhesive mesh onto the fabric. Place the petals on top, either in a grid or abstract pattern or loosely reassembled as the flower shape. You can, of course, create a new species! Make sure the petals are in a single layer and not overlapping. Separate the backing paper from the mesh of the second piece of Bondaweb and very

carefully lay it on top of the petals. You will find that the petals move slightly but this adds to the spontaneity of the design.

Now cover the four-layer sandwich – fabric, mesh, petals, mesh with baking parchment (silicone paper). It is essential to use baking parchment and not ordinary grease proof paper which would stick forever to the mesh. Set your iron to medium hot (cotton setting) and iron firmly. Whilst still warm, carefully peel the baking parchment away to reveal the petals trapped on the fabric between the two layers of adhesive mesh. It will feel quite sticky at this stage but this disappears as it cools.

The result is always exciting. Silk fabric will usually darken and almost has a leathery feel to it – the petals may or may not darken or change colour. A bright mauve pink

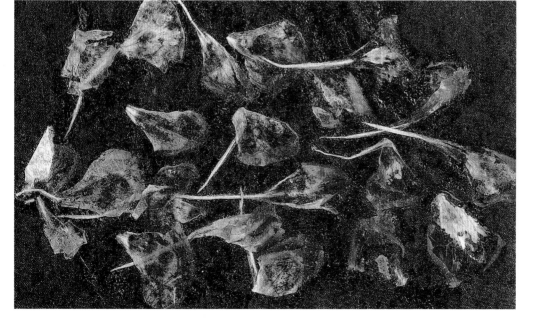

Dianthus petals bonded onto silk fabric

Above Pattern for hydrangea carrier bags. Englarge to A4 size for the smaller bags and A3 for the larger bags

Below Small carrier bags with fresh hydrangea flowers bonded onto silk fabric

Hydrangea carrier bags

A fresh hydrangea flower is papery and flat, and can be used without separating the petals. Snip off the stalk and, if the petals are curled as on some varieties, place the flower under tissue paper and press with a warm iron to flatten them. Enlarge the carrier bag pattern to A4 size or larger and cut the pattern out on the solid lines. Cut the fabric to the exact measurements of the pattern. The fabric needs to be firm enough to hold the shape of the bag and, although the layers of mesh do stiffen it, silk, for example, will need strengthening or backing before applying the flowers. This can be done with an iron-on interfacing (preferably dyed or sponge printed) or by bonding painted papers, brown paper or hand-made paper onto the back of the fabric, again using Bondaweb.

When your fabric is cut out and suitably stiffened, lay the first piece of adhesive mesh on top, arrange the hydrangea flowers to your liking and then add the second layer of adhesive mesh. Cover with baking parchment, iron firmly, then peel off the parchment. When quite cold, make up the bag, folding the fabric on each of the dotted lines over the edge of a steel ruler. Use a strong craft glue to secure the folded top edge to the inside, and to join the side and bottom sections. Glue a piece of fabric-covered card inside the bottom of the bag.

clematis, 'Comtesse de Bouchaud', turned to deep violet, almost black, which looked interesting. Pelargoniums, on the other hand, retain their natural fresh colouring.

On a thin fabric the surface will become quite textured, whereas on a firmer fabric such as calico it remains smooth.

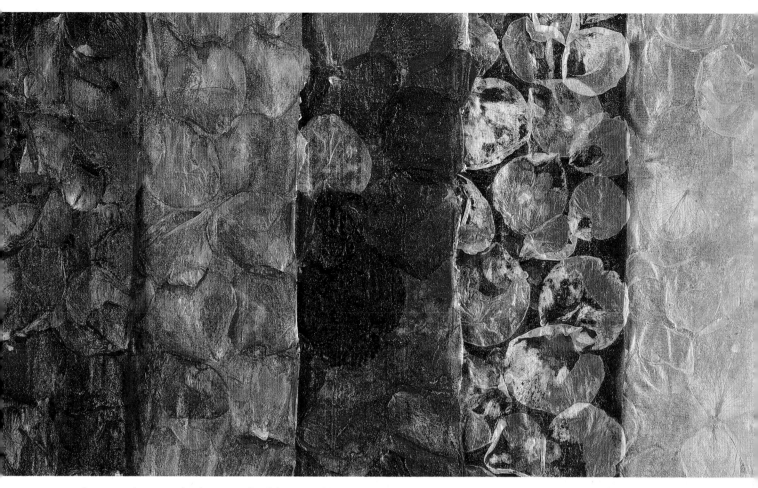

Eyelets can be punched or stitched by hand into the top of the sides to take plaited or twisted cord handles. Try using garden twine for a rustic look or add little tassels for a more decorative effect. These bags can be used to display dried flowers and would make the perfect container for pot pourri or an extra special present.

Rose petal fabric

It is always a delight to work with rose petals. Perhaps it is the perfume, the rich glowing colours or just a love of the English rose. Choose flowers with fairly small petals, separate them from the flower head and leave them to go limp. The best plan is to pick the flowers in the late afternoon and leave them overnight, spread out in a single layer in a warm room. The next morning, iron the petals onto fabric between two layers of Bondaweb adhesive mesh, not forgetting the top covering of baking parchment (see page 11). A medium-weight silk, such as dupion, is ideal. When cool, this fabric can be used to make

Above Fresh rose petals of different colours bonded onto silk fabric

Below Small bag made with rose petals bonded onto silk with beaded edge, plaited cord and beaded tassels. Rose petal fabric used to wrap a box, tied with machine-made braid

13

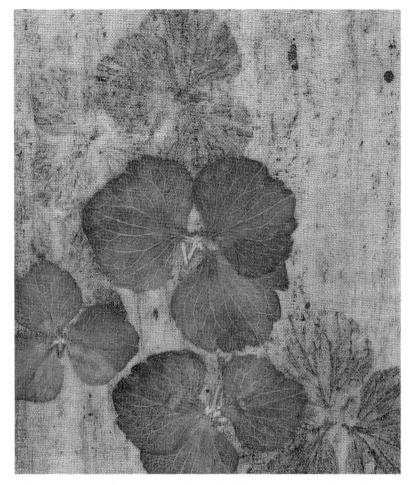

Above Hydrangeas bonded between painted calico and organza with added flowers printed onto the calico backing

Right Hardy geraniums bonded between calico and organza

Far right The background is worked in close lines of darning stitches using silks, stranded cotton and fine wool

printed or sponged with fabric dyes to add interest. Place a piece of separated Bondaweb mesh on the background fabric and arrange the flower petals in either a naturalistic arrangement or an abstract pattern. Cover with a second piece of adhesive mesh before adding a layer of sheer fabric such as organza, chiffon, net or very fine silk. Cover with baking parchment and iron with a medium-hot iron.

Many variations of this technique will occur to you. The sheer fabric can be torn into strips and applied overlapping with frayed edges. Dried flowers, crumbled between the fingers, can be added to give background interest, as can fine grasses and leaves. It is quite easy to get carried away with this process, forgetting to leave any

precious little bags, encrusted with beads and with added braids, fringing and tassels. Although they may not last for ever, the fabric is far more durable than you might think. Imagine a little present wrapped in rose petal fabric – I just hope the wrapping paper will not be thrown away!

Petals under sheer fabric

For a more permanent stitched embroidery, try sandwiching petals between two layers of fabric, the top fabric being sheer or translucent to allow the petals to show through. The background fabric should be reasonably firm and can be painted,

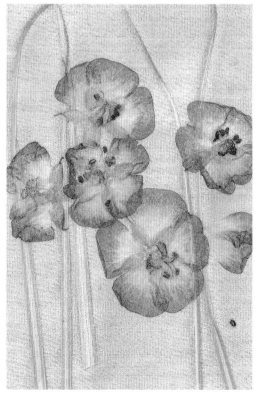

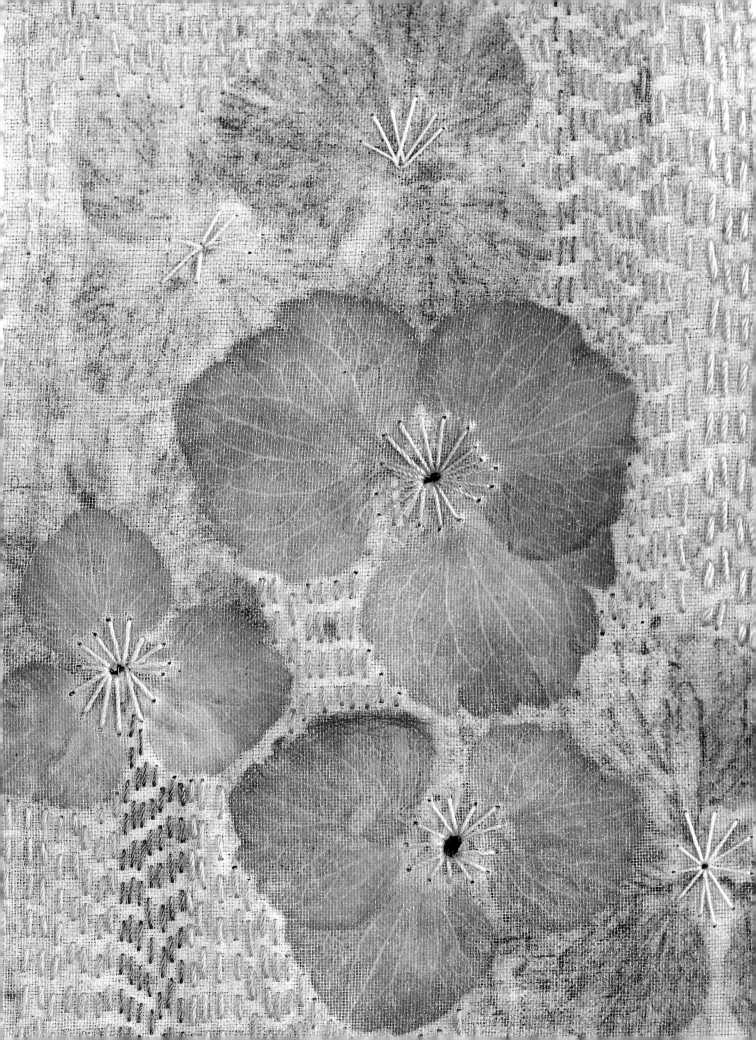

space or purpose for the stitching. Often, however, you will want to work the background or negative shapes with darning, straight stitches or seeding; techniques which help to integrate the flowers with the background fabric. The applied petals can be worked with straight stitches to emphasize the veins, with the obvious choice of eyelets or French knots for the flower centres. You may feel a little cautious about stitching directly into the delicate petals. Use a fine needle and thin threads, and remember that the sandwich of fabrics is a lot tougher than it looks!

Rose petal beads

Having experimented for some time making fabric beads using Bondaweb instead of the more usual glue method, it seemed logical to try the same technique with rose petals. Cut a piece of Bondaweb approximately 13 cm (5 in) square and lay it with the rough adhesive side uppermost. Arrange limp rose petals as close as possible to cover the area but not overlapping. Cover with baking parchment and iron with a medium-hot iron. Peel off the baking parchment carefully and leave to cool. Cut into wedge-shaped pieces, using the diagrams on page 18 as a guide. It is not necessary to mark exact cutting lines as slight irregularity in the bead sizes adds to the attraction. Very gently peel the paper backing away from the

petals. Using a piece of firm wire (a round bodkin, a toy-making needle or a fine knitting needle), roll the strip of petals round the needle, starting with the wide end and with the adhesive on the inside. When the tip is reached, roll the bead round and round onto a warm iron, still on the needle, to allow the adhesive to seal and secure the bead. This may seem a bit fiddly at first but practice does make perfect and by the second or third bead, you will see how easy it is. Slip the bead off the needle and leave to dry. If the bead sticks to the needle, let it cool then twist it round and round on the needle before slipping it off.

Left in their natural state, the colour of red rose petal beads will fade to a delightful soft creamy brown with tinges of violet. To preserve the colour, paint the beads with matt clear varnish. This also hardens them, making them suitable for necklaces, bracelets, earrings, tassels or wherever else you choose to use beads. Other flowers can be tried for beadmaking, with the proviso that they have thin, papery petals.

Left Dianthus petals bonded between silk and organza

Right Dianthus petal fabric as shown, with added fragments of silk held in place with short rows of overlapping buttonhole stitch

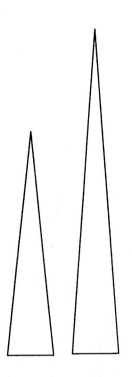

Above Patterns for rolled rose petal beads. The longer the strip, the fatter the bead

Right Pelargonium petals bonded between calico and torn strips of organza with added petal fragments and straight stitches, with loosely worked knotted balls in the centre of each flower

Pulped rose petal beads

There is a fascinating connection between rose petal beads and the rosary or prayer beads used in the Catholic Church. Research shows that the name 'rosary' may have been taken from a garland or circle of roses but, more probably, the beads themselves were made from rose petals. This recipe for making beads from pulped roses may appear to have more affinity to a cookery book than anything to do with embroidery or horticulture, but I promise it is great fun to do.

The quantities of both the roses required and the number of beads made are obviously approximate. Pick as many roses as you can. They need not be in prime condition; deadheadings

and fallen petals are suitable as long as they are not totally dry. Keep an eye on your neighbours' gardens as they can often be persuaded to contribute their deadheaded roses too. Roses can be kept in the refrigerator in a polythene bag for several days until enough have been collected. Separate the petals, removing any bits of the calyx, sepals and stamens. Put a handful of petals into a liquidizer, running the machine for short bursts, to chop the petals very finely. Keep adding petals, putting the chopped petals into a plastic container; cover with a lid or clingfilm and keep in the refrigerator for twenty-four hours. Remove the petals from the container and repeat the process in the liquidizer to further pulp them. Put the mixture into a bowl and work with your hands, rather like shortcrust pastry, until it clings together and forms a ball. Take a small quantity and roll it between your palms to make a ball, about the size of a chocolate truffle; remember it will shrink to at least half its size when dry. Make a variety of sizes and place them on a piece of kitchen paper, not touching, to dry out – remind the family that they are not truffles! After a day or two, depending on the air temperature, the surface will have dried out. At this stage push a cocktail stick through the centre of each bead. Push the sticks into a piece of polystyrene foam to allow the beads to dry out completely.

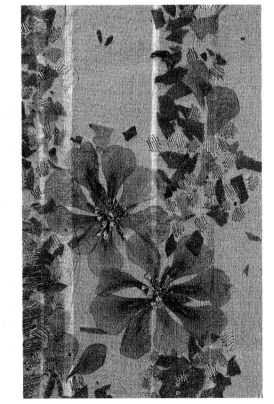

Rose petal bead and rose
quartz necklace. Fresh rose
petals ironed onto bondaweb,
cut into wedges to make
beads with a toy making
needle

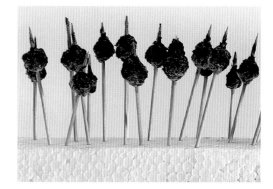

Opposite Pulped rose petal beads left to dry on wooden cocktail sticks pushed into polystyrene

Below Rose bead books Rose petal beads stitched onto silk fabric, backed with felt and embellished with small round beads. The darker rose petal beads have been painted with matt clear varnish to preserve the colour while the paler beads have dried naturally

Do not worry if a white bloom appears on the surface; at first I thought this was mould forming, but it does not seem to prevent the beads from drying rock hard. When completely dry, remove the cocktail sticks and brush the surface with a metallic wax gilt (used to restore gold leaf) or metallic fabric paint. A coat of matt clear varnish will give extra protection. Traditionally rose petal beads were preserved with lamp black but I had some difficulty obtaining this from my local hardware store. The slightly rough textured surface gives these beads an ethnic feel and they will surely give that individual touch to any embroidery or jewellery project. Try to think of them as precious rose petals and forget that they are really balls of compost!

A final word on using roses: use the best small rose petals for rose petal fabric; the larger petals for making rolled beads and the less perfect petals for pulped beads. You will be able to enjoy roses in the garden or in a vase and, when past their best, in your embroidery.

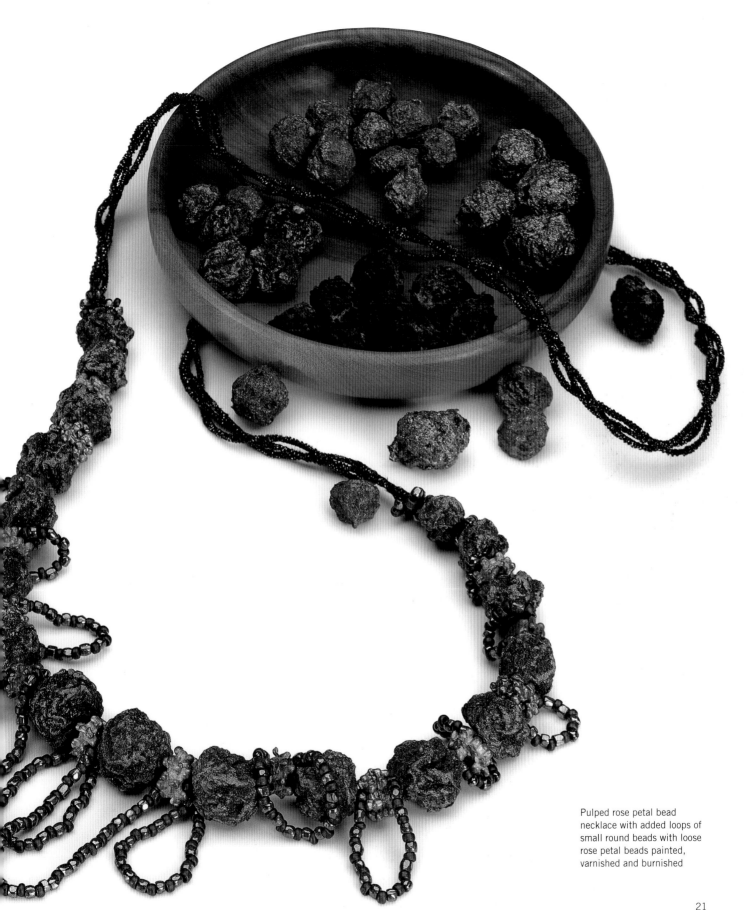

Pulped rose petal bead
necklace with added loops of
small round beads with loose
rose petal beads painted,
varnished and burnished

chapter two

Hand
Embroidery

chapter two

Hand Embroidery

There is something uniquely pleasurable about hand stitching. We imagine ourselves sitting quietly, frame in hand, with an array of brightly coloured threads, watching the design grow stitch by stitch. Many embroiderers start with a knowledge of hand stitchery but are constantly tempted to try different techniques seen in books, at exhibitions or in workshops and day schools. Appliqué and patchwork have us wrestling with a mountain of fabric, we make felt and hand-made paper, pull threads, create textures and distort fabrics, to say nothing of the hours spent mastering the sewing machine. All enrich the repertoire but a return to hand stitching can be a delight too.

Above Rudbeckias
Worked on painted linen with straight stitches and seeding using fine wool, silk and stranded cottons
Marion Brookes

Right Paeonies painted on calico with fabric paints and partially embroidered in long and short stitch with silk threads. Wrapped card to form a mount
Evelyn Jennings

Fabrics

There is a wide choice of fabrics which are suitable for hand embroidery. The main requirement is that the fabric is firm enough to support the stitches. Cotton, calico, linen, silk, furnishing and dress fabrics are all easily available from shops and department stores, as well as specialist embroidery suppliers. Translucent or lightweight fabrics such as silk should be backed with thin cotton or muslin. As well as stabilizing the work, a backing helps especially in the starting and finishing of threads, which would otherwise show through to the surface on a fine fabric. The majority of embroiderers today prefer to work on a frame, either a round ring frame or, for larger pieces of work, a slate or square frame. This is essential

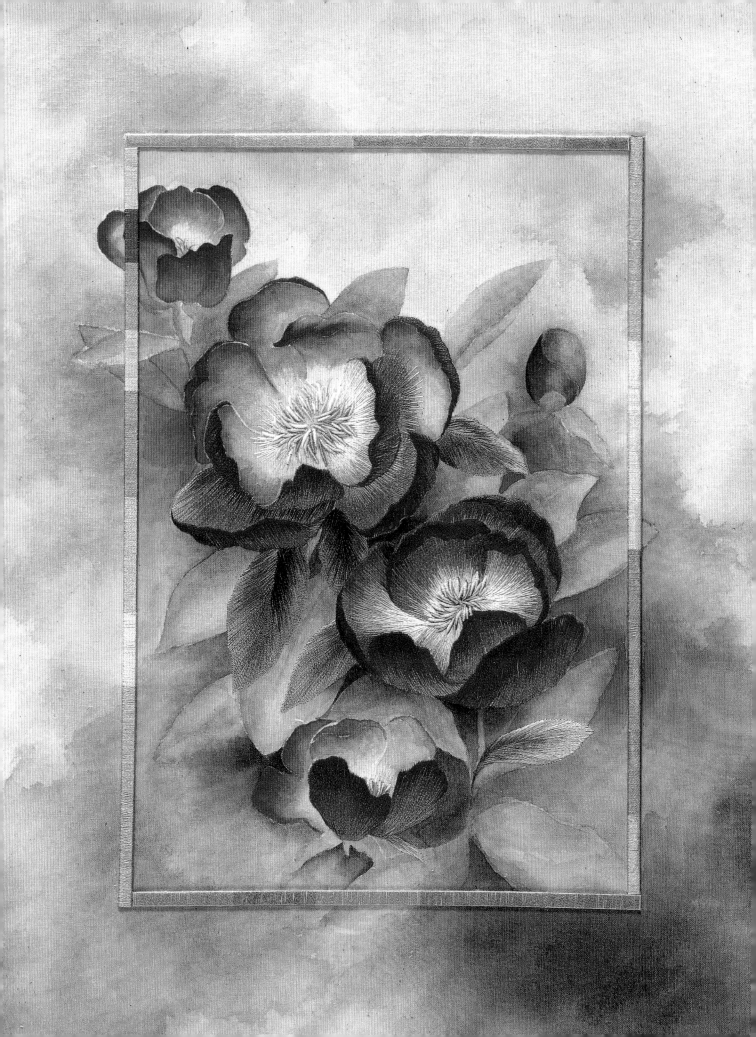

when you are working satin, straight or line stitches to keep the tension of the stitches smooth and flat.

Colouring the fabric

A large expanse of plain fabric can seem a little daunting when you are starting any embroidery project. It is a great help to add colour to the fabric with the wide range of fabric paints and dyes available. Always read the manufacturer's instructions but have the confidence to experiment a little too. There are specialist books devoted to fabric painting (see Further Reading on page 124) which cover a multitude of different effects. However, even the simplest techniques will enhance the subsequent stitching, with an indication of dappled foliage and flowers in the background.

Wash the fabric to remove any surface dressing, dry and iron to remove creases. Pin or tape the fabric onto a board which has been covered with a water-resistant sheet. Put two or three blobs of different colours of fabric paint onto an old plate, mixing each with a little water. Allow – or encourage – the colours to run into each other. Take a piece of sponge, a fat stencil brush or a roller and dab it into the fabric paint, absorbing a mixture of colours. Have some spare paper to hand and print onto this first, both as a check and also to remove the excess paint. Then print onto the fabric several times, overlapping each print slightly, before dabbing into the fabric paint again. It helps the colours to merge if the fabric is damp. If the colours look too strong, wet a brush or sponge with clear water and work into the area to dilute the colour further. Remember, too, that the colours will be paler when dry. Most fabric paints are heat-set with an iron, but check with the manufacturer's instructions as different brands vary slightly. With a little experience, more intricate and complex designs can be printed or painted onto the fabric and your confidence will grow every time you use fabric paints.

Designing with flowers

Colouring the fabric with fabric paints will often suggest starting points for designs. Unexpectedly bright spots or specks in the printing may suggest

Photocopies of fresh hydrangea flowers

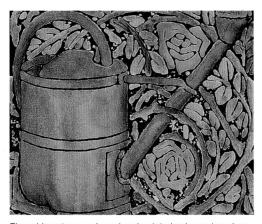

The rubber stamp enlarged and painted using watercolours
June Carroll

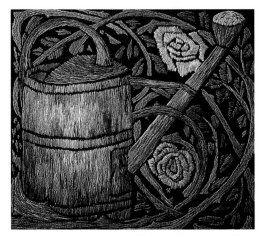

Watering can and roses embroidered using a variety of
threads in split stitch, long and short stitch, stem and
straight stitch
June Carroll

flower centres with straight stitches
radiating from them, partly overlapping
each other. This is much closer to real
nature than the 'full-frontal' flower
with a straight stalk and two leaves
which featured in childhood
embroidery of the transfer variety.

Take a simple flower such as a
hydrangea, impatiens or hardy
geranium. Brush fabric paint onto the
petals, streaking then with a second
colour or a metallic paint. Hold the
flower by its stalk and print onto the
fabric, pressing gently with your

fingers. A perfect reproduction of the
flower will not usually happen – nor is
it intended to – but you will have part
of the shape, form and outline of the
flower on the fabric to enhance with
stitching. Parts of the flower can be
stitched completely, covering the
printing, which is particularly effective
if certain areas are not quite to your
liking. An alternative method is to
place the flowers on the fabric, held
in place with a minute piece of double
sided sticky tape, and to sponge fabric
paint onto the surrounding areas.
The flower shapes are then shown
with a mottled and dappled back-
ground, giving you the choice of either
embroidering the flowers, the back
ground or perhaps, a little of each.

Using rubber stamps

A simple design source for embroidery
can be found in the revived interest in
rubber stamps; many of which feature
both realistic and abstract flowers.
A look at the collection at craft fairs
and in specialist catalogues shows
the quality and variety now available.
Although many are too small to
translate directly into an embroidery,
they can be printed onto paper and
enlarged to any size with the aid of a
photocopier. Try using several different
sizes of the same stamp in a design;
work out alternative colour schemes
for the embroidery on the photocopies,
using paints or crayons.

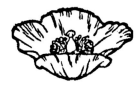

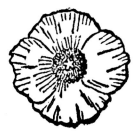

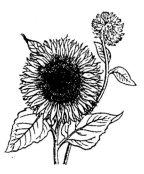

A variety of rubber stamps
showing flowers

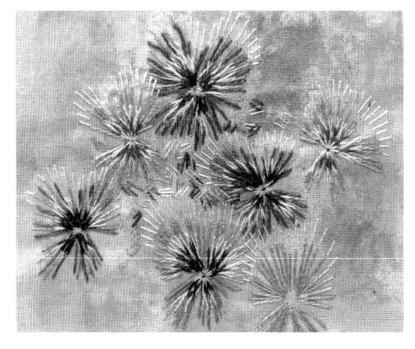

Above Painted calico with flowers worked in straight and cross stitches and eyelets
Marion Brookes

Right Rose embroidered in silk on silk brocade fabric. Detail of a Chinese Robe
Sheila Paine's collection

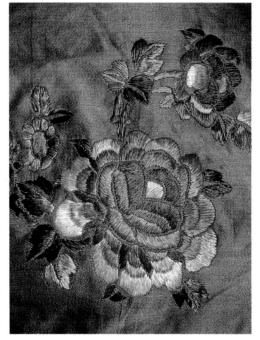

Flat stitches

Look again at the familiar and sometimes neglected group of flat stitches – stem, satin, split, long and short and straight stitches; instructions for which are shown in virtually every embroidery stitch book. Long and short is known by many names including brick stitch, shading stitch and featherwork (not to be confused with the more modern feather stitch) and, historically, as *opus plumarium*. This last term appears in inventories of the Middle Ages describing embroidery resembling feathers and may be long and short or satin stitch. Some of the finest examples of satin stitch can be seen in Chinese embroidery: whenever you have the opportunity, visit museums or private collections to marvel at the full-length robes of silk brocade, heavily embroidered in metal and silk threads, depicting roses, paeonies and all manner of exotic flowers. Ideas for modern interpretation in your own work can be found in both the design and the techniques.

Flat stitches are ideal for shading and showing the play of light on flower petals and leaves, the sheen contrasting beautifully with the more textured areas of the design. Traditionally these stitches were worked in stranded silk or cotton but today we have a greater choice of threads. Try using the fine rayon, cotton or acrylic machine embroidery threads, perhaps using a number of strands together in the needle, either the same or different colours. Fine crewel wool, also intended for machine embroiderers, gives a matt contrast to the shiny threads. Rayon floss is also available instead of the silk floss which is now

difficult to find. Variegated and shaded threads, either commercially produced or your own dyed or space-dyed threads, add another dimension to these stitches. Small quantities of fine threads can be dyed easily at home. Take a piece of firm card and cut a small slit at one end. Wrap thin threads around the card, starting and finishing in the slit. Include different natural fibres such as silk, rayon, cotton and linen, as each will take the colour slightly differently. Sponge or brush the threads with fabric paint, working with several colours to achieve a shaded or variegated effect. To heat-set the paints on thin thread, iron them whilst still on the card. For thicker threads it may be better to use a hairdryer, with the threads either on or off the card.

Line stitches

Many of the traditional line stitches illustrated in diagram form look very rigid and uninspiring; the only criteria seeming to be even spacing and straight lines. It is necessary, in the first instance, to learn how to work the stitch correctly. Once familiar with it, start varying the spacing and the length of each stitch; work them in wavy lines, isolate parts of the stitch, repeating them, and overlap one row on top of another. You can use a thin

Printed flowers on evenweave linen with back stitch, thorn stitch and eyelets
Marion Brookes

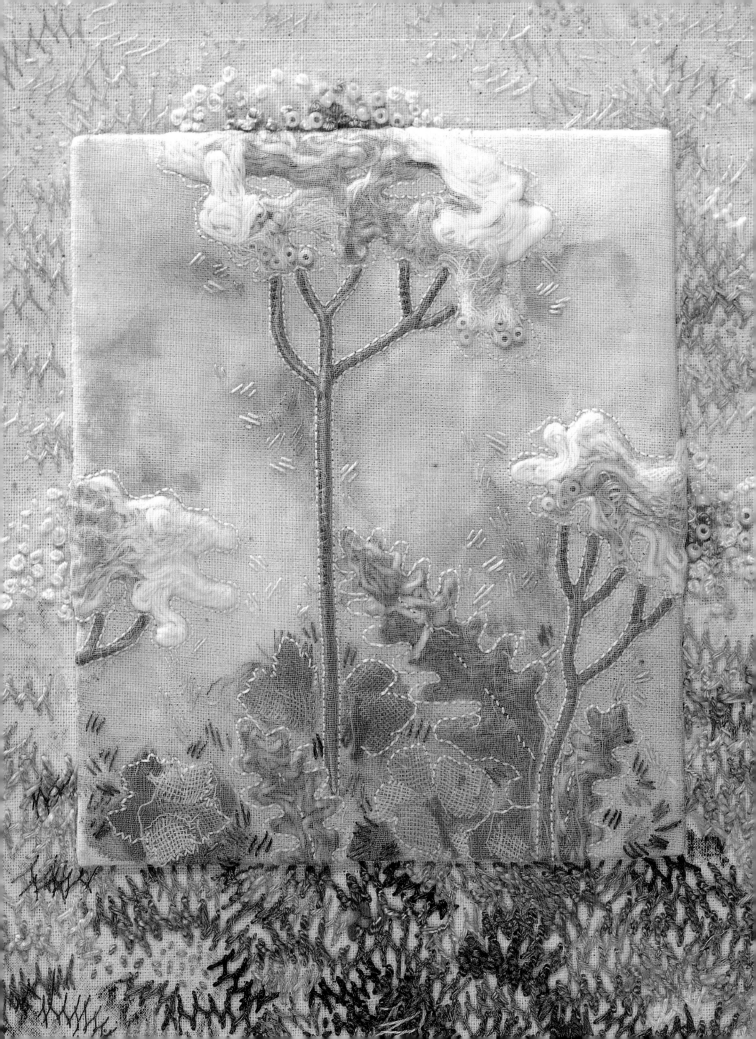

thread rather than the thick thread which is generally illustrated in stitch diagram books. Add to this a shaded or variegated thread and you will soon have a field of corn, waving grasses or drifts of flowers instead of the straight lines you started with. Ideal stitches to practise with are cretan, vandyke, herringbone, fly and buttonhole and you will find many others in stitch books.

Textured stitches

Most embroiderers love to work French knots and they are one of the most useful stitches to depict the clusters of tiny flowers which abound in spring. Think of aubretia, alyssum and lobelia, the rock garden clothed in colour, and you think of French knots. The scale and texture of such areas can be enhanced by using a variety of different threads, matt and shiny. This surely captures reality, with the sun shining on some flowers whilst others are shaded. Try working the knots in unusual threads such as lengths of thin ribbon, knitting ribbon yarn, thin threads massed together in the needle and torn strips of fabric. This will give depth and weight to the centre of an area, contrasted with smaller knots worked in more usual threads at the edges. As well as working French knots in the correct way, see if you can vary them by stitching rather badly! Let little loops emerge and work one on

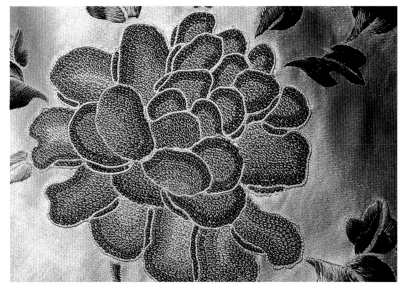

top of another to build up an uneven, textured area. When using thick threads or strips of fabric it is difficult to pull the needle through, especially if the fabric is fine or closely woven. Use a very large-eyed needle, almost a sharp pointed bodkin, and resort, if necessary, to making a hole in the fabric in the appropriate place with a stiletto before bringing the thread through. Pulling and jerking on the needle is very tiring and is liable to distort the fabric.

Cross stitch

Cross stitch is usually thought of as a very regular stitch worked on evenweave fabric following a precise chart. It can look quite delightful and very different if worked freely as a textured area. Stitching crosses at random in massed areas gives an impression of drifts of tiny flowers, providing yet another method of interpretation. When only one 'arm' of

Above Detail of a Chinese theatrical costume showing a flower worked entirely in Chinese knots using silk thread
Sheila Paine's Collection

Left Detail of Achilleas showing small applied panel of Italian and trapunto quilted shadow work with fragments of space-dyed muslin and textured threads
Marion Brookes

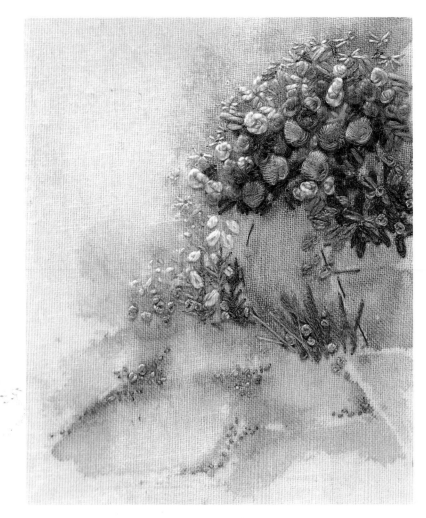

Painted calico with French
knots, eyelets, straight
stitches and detached
chain stitch
Marion Brookes

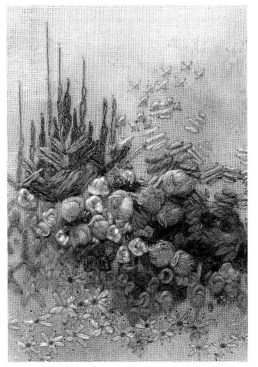

the cross is worked, perhaps at the edges of an area, you have moved into seeding. This is a versatile stitch, scattered over the fabric, giving a shadowy effect. Work it in a variety of different thicknesses of thread, densely in places and sparsely in others.

Eyelets

Groups of eyelets are an attractive addition to a textured area of stitching. They can be worked quite neatly or freely, depending on the desired effect. Whatever the choice, the central hole is important and should be left 'empty' of threads. This is achieved by bringing the needle up at the outer edge of the eyelet and taking it down into the centre, with the needle held upright rather than at an angle. A little pull on the thread each time will ensure that the central hole remains open, getting bigger if anything, not smaller. Vary the length and spacing of the stitches; work only half an eyelet, as though overlapped by another; and, of course, vary the sizes. In the traditional technique of broderie anglaise, the eyelets have large holes, with the stitching around the edges appearing less dominant. The hole is made first with the help of a stiletto before the edges are overcast with a fine thread.

Far left Broderie anglais on different space-dyed silks which have been pieced together; straight stitches using cotton perlé

Left Chimney Pot Design taken from a garden photograph embroidered in a variety of stitches including stem, seeding, random cross stitch, long and short stitch, French knots and detached chain stitch
Anita Gladman

Below Detail of Victorian cloth embroidered in long and short stitch using perlé thread, outlined with Jap gold

Ribbon yarn

Ribbon yarn, usually sold for knitting, is very useful for creating massed areas of small flowers. It is available in larger knitting wool shops, department stores and in small quantities from specialist embroidery suppliers. As well as plain colours, it is available in rainbow dyes and several metallics. Rather than purchasing vast quantities of each colour, buy a large ball of white ribbon yarn and colour it yourself with fabric paints. Make sure it is rayon, however, as the nylon and acrylic fibres will not take the dyes successfully. Using a large-eyed needle, try a variety of stitches. Perhaps the simplest straight stitches and French knots are the most effective.

As well as stitching with ribbon yarn in the needle, take a short piece

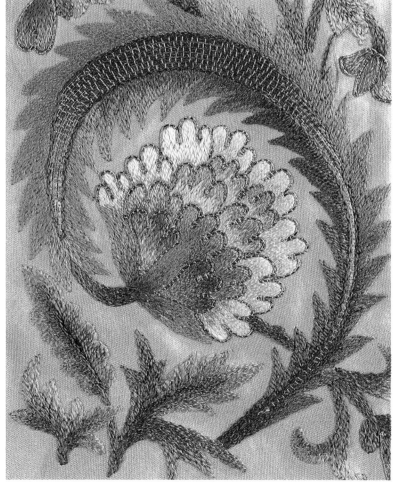

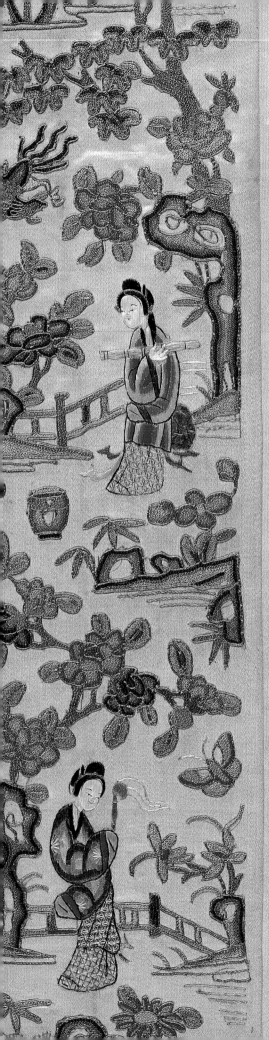
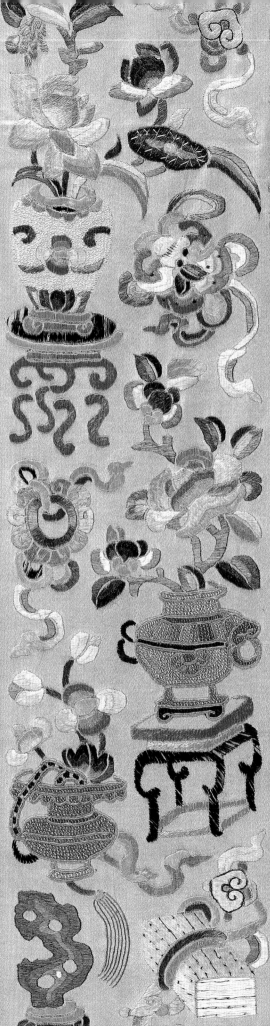
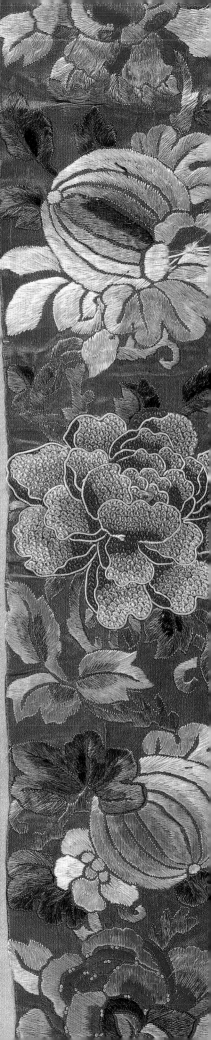

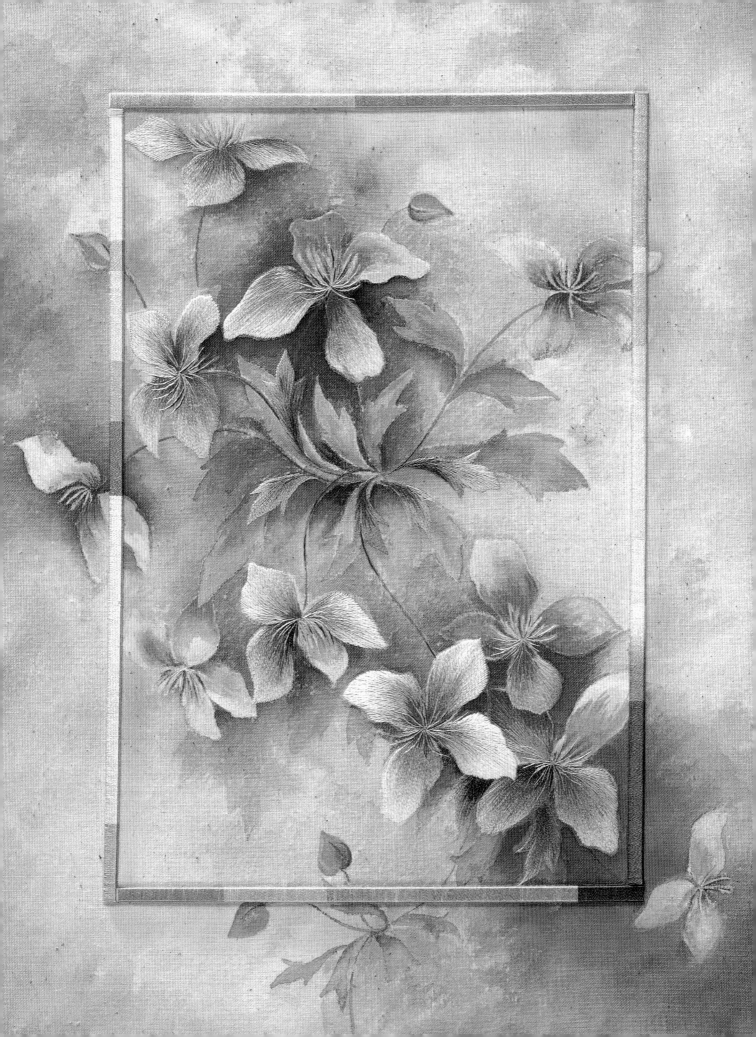

Previous spread, left
Three bands of Chinese
embroideries. Worked on silk
fabric in silk threads using
satin stitch, stem stitch,
Chinese knots and metal
threads

Previous spread, right
Clematis
Painted on calico with fabric
paints and partially embroidered
in long and short stitch with
silk threads. Wrapped card to
form a mount
Evelyn Jennings

Opposite Detail of an Indian
organdie table cloth with satin
stitch flowers outlined with gold
and applied beetle wings

and unravel it. This is easily done with
the help of a pin or the end of your
fingernail, pulling hard on the cut end.
Ribbon yarn is made in the same way
as old-fashioned French knitting and
there are many childhood memories of
how easily that unravels. You will now
have a crinkly, stretchy, textured
thread, quite unsuitable for use in the
needle but wonderful for couching
onto the surface of the fabric. Thread
your needle with a fine thread in a
matching or contrasting colour and
work little stitches over the unravelled
ribbon yarn to couch it in place. Push
and guide it into little massed areas,
adding French knots if you wish.

Pelmet Vilene 'sequins'

Another interesting texture is made
with an oddment of pelmet Vilene.
This is sold in department stores in
the curtain fabric section, in either a
narrow strip or by the metre. Sponge
fabric paint or dye onto the Vilene in
'garden' colours and leave it to dry
overnight. Using a leather punch,
punch out little circles which look
rather like sequins. These are much
nicer than shop-bought sequins which
tend to be harshly coloured and far too
shiny for an English country garden.
Pelmet Vilene 'sequins' are soft and
come in subtle, matt colours. Sew them
onto the fabric with a little stitch or
two, pushing them close together so
that some of them appear to stand up.

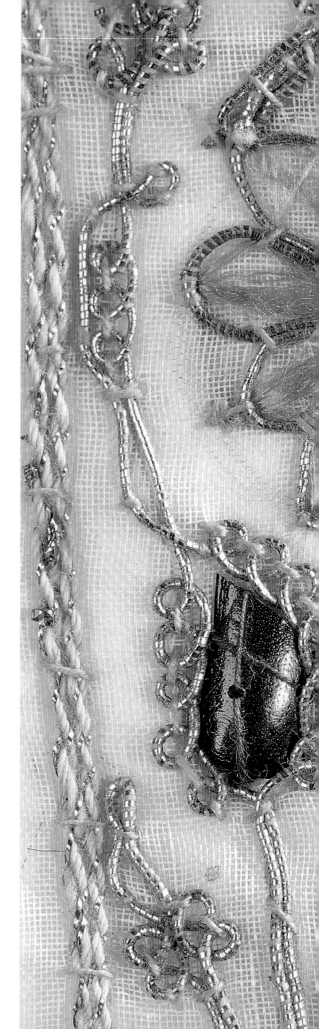

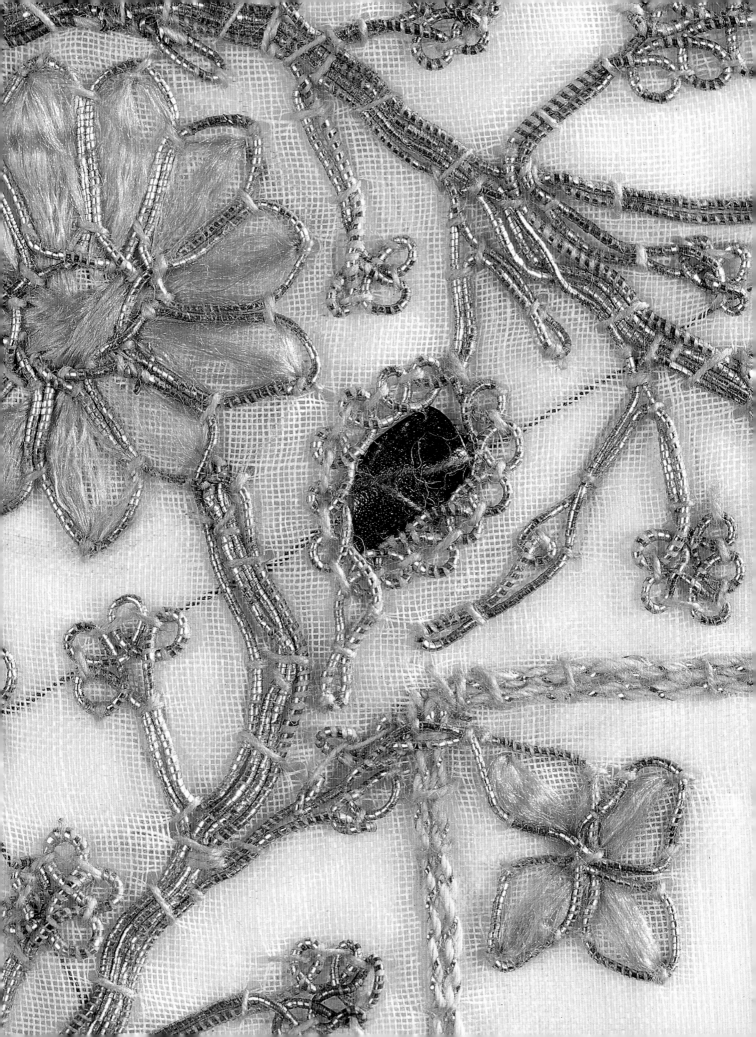

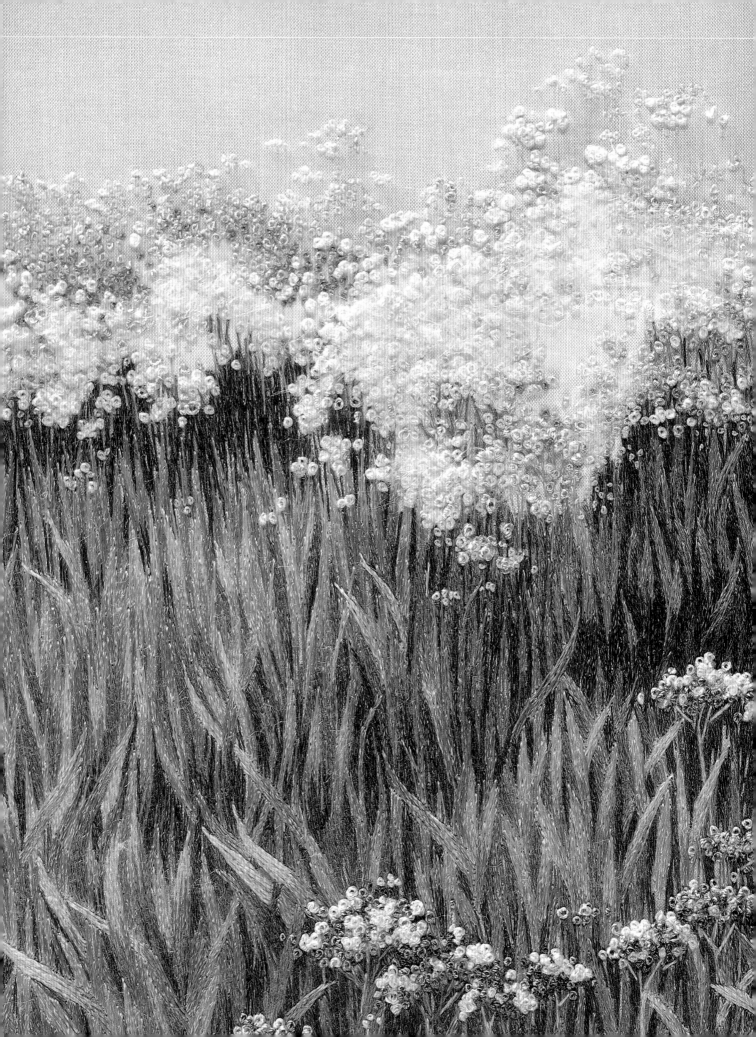

Cow Parsley
Hand embroidered on
painted silk using a variety
of different threads including
floss, stranded cottons and
machine embroidery threads
Evelyn Jennings

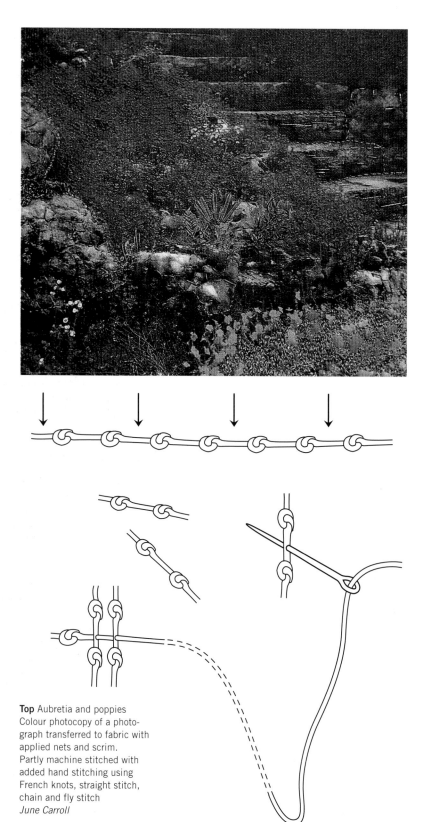

Many leather punches have different-sized holes, which gives added interest. If you do not have a leather punch, try using a paperhole-punch instead, though this will only give you one size of hole. After punching out lots of circles, you could snip the remaining pelmet Vilene into tiny fragments and stitch them onto the fabric for a richly textured area. The fragments could be held in place with irregular cross stitches worked over them or surrounded by French knots.

Knotted balls

Knotted balls were much in evidence in Victorian households as the ultimate decorative fringing technique. They were used as an edging round cushions and footstools, on curtains and over mantelpieces. These little round balls of knotted threads can, however, be used as raised texture sewn onto fabric, providing three-dimensional French knots. These are shown as the centres of clematis flowers on page 18.

The method for making a knotted ball is to take a length of thread, approximately 45 cm (18 in) long. Perlé No 5 is ideal for your first practice ball but, with experience, many different threads can be used. Make a single knot in the centre of the thread and continue to make knots all the way along to the end, spacing the knots 6 mm (1/4 in) apart. Work from the centre knot to the other end of the

Top Aubretia and poppies Colour photocopy of a photograph transferred to fabric with applied nets and scrim. Partly machine stitched with added hand stitching using French knots, straight stitch, chain and fly stitch
June Carroll

Above Knotted balls, showing the knotted thread and individual cut 'beads'. Pick up the beads on the needle to make the knotted balls

thread in the same way. Hold both ends of the knotted thread and pull tightly to ensure that all the knots are firm. It is much quicker to knot short lengths of thread and, with a little practice, it becomes quite easy to slide the knots to the correct distance apart. The space between knots depends to an extent on the thickness of the thread used; with a thicker thread the knots can be further apart, while a finer thread requires closer spacing. The distance between the knots should be consistent and accurate for a neat, rounded ball. Should this regularity seem difficult to achieve, the end result will certainly not be round but it could still be very interesting! When all the knots have been made, cut the thread between pairs of knots as shown opposite. Place the pieces of thread (or 'beads' as they are known) onto a soft surface. Put a short length of the same thread into a large-eyed needle, making a firm or double knot at one end. Pierce the centre of each 'bead' between two knots, sliding them onto the needle and along the thread to the knotted end. About twenty 'beads' will give a nicely rounded ball. Take the needle through the background fabric at the desired position, with the ball resting on the surface. Fasten off the thread on the back of the fabric.

Right Detail of Japanese coat embroidered all over with silk floss padded satin stitch
Sheila Paine's collection

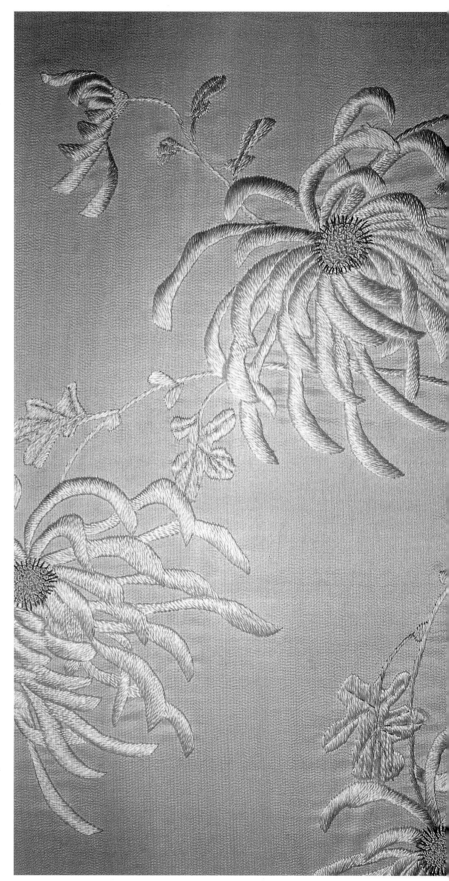

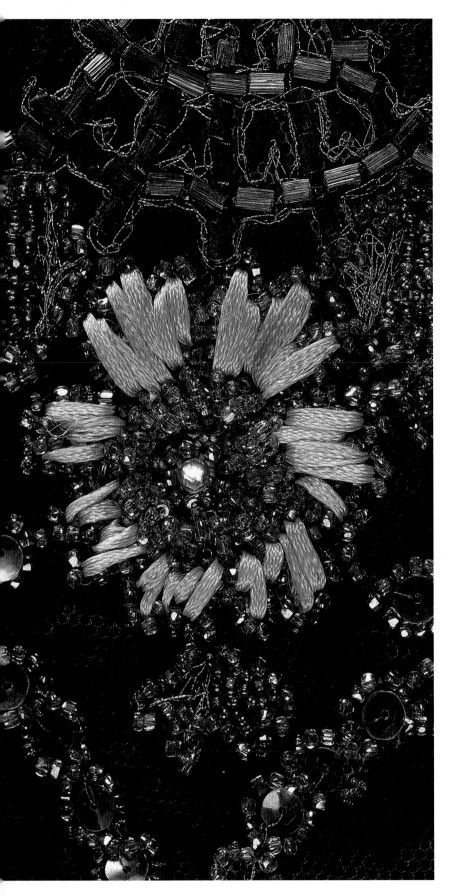

Having made the first ball using perlé, it will be obvious that many others threads could be used, giving very different effects. Try thin strips of chamois leather, knitting ribbon yarn, thin ribbons or strips of stockings or tights. Even thin strips of fabric can be used, giving a rather wild, frayed and hairy ball, suitable for a larger-scale piece of work. It may be tempting to use the shiny metallic threads and braids which are now available, but many of these will not hold a knot securely and tend to work loose, whereupon the whole ball will fall apart.

This, of course, leads to another avenue of thought – using the individual beads as they are. Work the knotting as described above, including cutting between pairs of knots. Thread a needle with an ordinary embroidery thread such as silk twist or stranded cotton. Take a single bead, that is a very short length of thread with a knot at each end, and couch it onto the fabric with a small stitch through the centre. Pulled tight, this will make the two knots stand up from the surface. Use in a massed area of textured stitching or around the more conventionally worked knotted balls.

Using a photocopier

Some interesting and experimental work has been done in the last few years using photocopying machines.

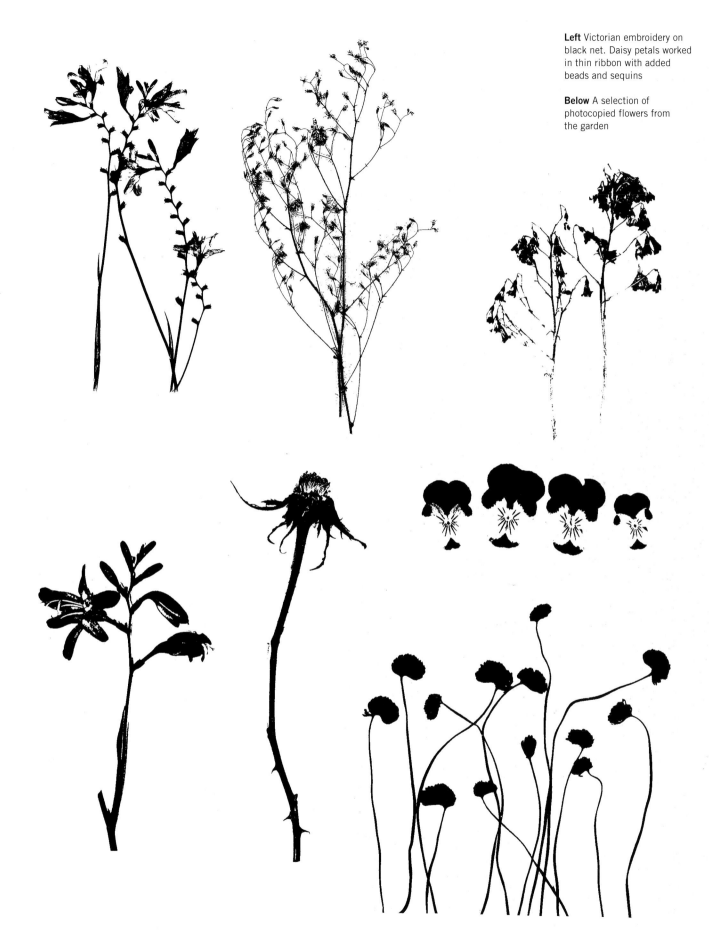

Left Victorian embroidery on black net. Daisy petals worked in thin ribbon with added beads and sequins

Below A selection of photocopied flowers from the garden

43

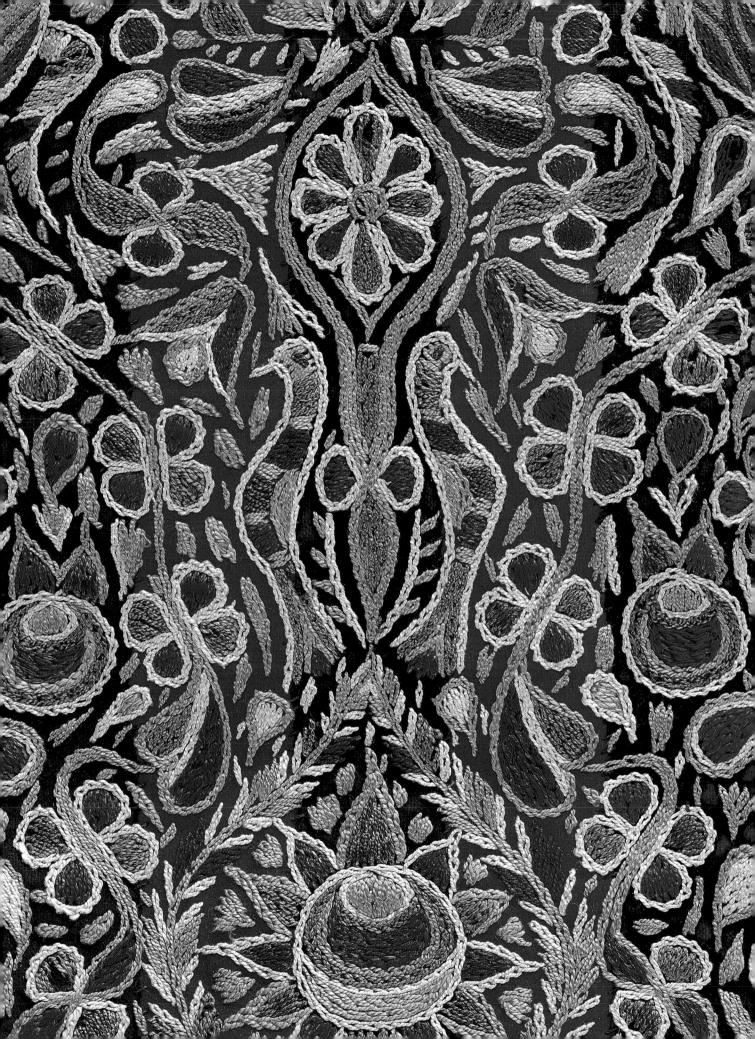

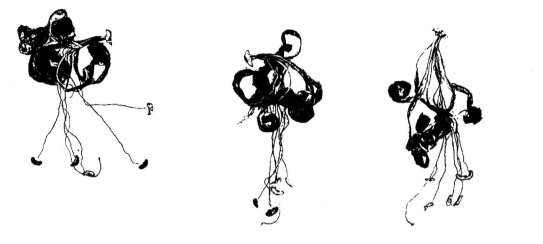

Apart from the obvious and very useful method of enlarging and reducing designs, there are other benefits of having access to a friendly machine. A favourite technique is to place a real flower on the glass plate under the top lid, thus producing an instant 'drawing'. Cheating, perhaps, but this can be an excellent starting point for a design. Try selecting certain areas, repeating them, rearranging them, cutting the photocopy into strips, weaving with the strips, or dramatically enlarging or reducing parts of the flower. With your input, a design emerges which is your very own work. However, be selective about the flower you choose for this. Many quite pretty flowers photocopy as uninteresting round black blobs, to say nothing of how a dahlia or chrysanthemum would appear! Choose a light, feathery flower spike of heuchera or the well-spaced flowers of freesia or montbretia. Individual flowers can be photocopied too – hydrangea and pansy are obvious choices. Nerines, with their crimped

and sometimes twisted strap-shaped petals, are wonderful additions to the late autumn garden when alive, and become even more interesting when dead. The petals remain on the flower, twisted and contorted, providing endless scope for design.

Printing photocopies onto fabric

An intricate design can be transferred to fabric from a photocopy and, although this method might not be suitable for all types of embroidery, it can be very useful in the right place. Some embroiderers use this technique very happily, others find it less successful. Follow the method exactly, trying not to rush or cut corners.

You will need white spirit (not turpentine), washing-up liquid, a jamjar, a newspaper, a 2.5 cm (1 in) paintbrush and plain paper. Put 1 tablespoon white spirit into the jamjar. Add 2 tablespoons of cold water. Add 1-2 drops of washing-up liquid, which acts as an emulsion. Put the lid on and shake well until the

Above Nerines
Photocopies showing the curled and distorted petals of the dead flower

Left Indian panel
Chain and stem stitch on cotton fabric

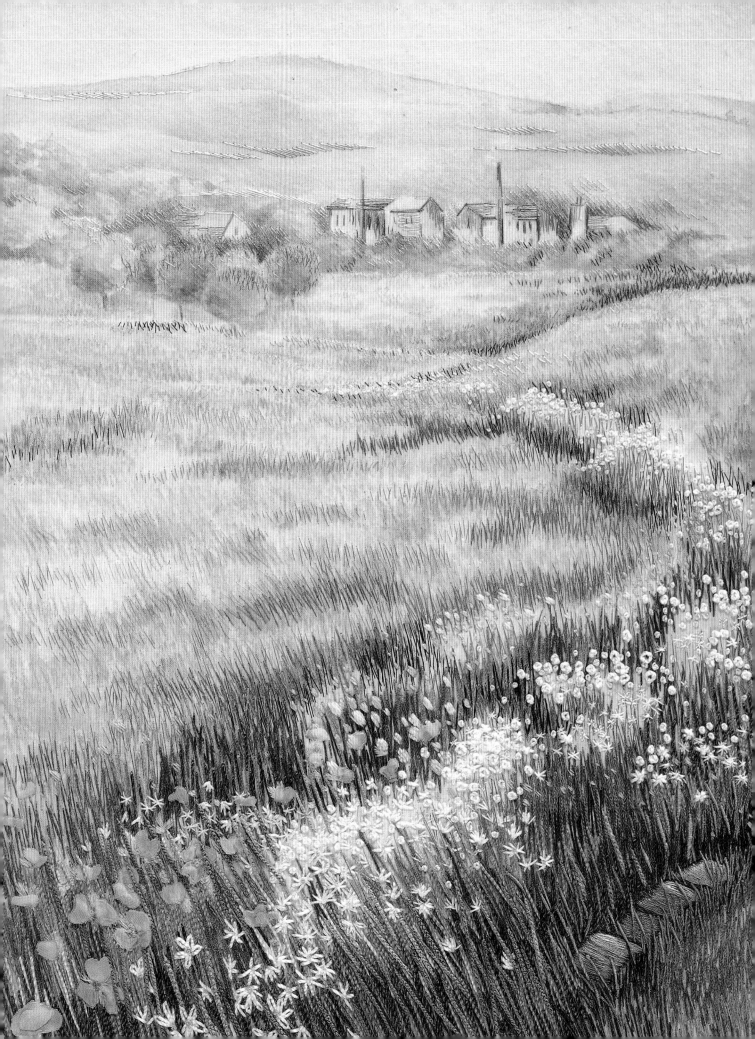

Far left Bingley, Yorkshire
Worked on calico painted with
water soluble pencils and
hand-embroidered in a variety
of threads including space-
dyed threads
Evelyn Jennings

Left and below A landscape
sketch photocopied and
printed onto painted silk,
embroidered with fly stitch,
French knots, ribbon yarn and
pelmet Vilene 'sequins'

Far right Darning with stranded cottons on cotton organdie

liquids are mixed. Select a newly printed photocopy of your chosen design, making sure that it is a good black copy and that the photocopier is not running short of its powder toner; if the copy looks a little grey, turn up the toner control. Place the photocopy, right side down, onto newspaper and brush with the mixture until the paper becomes translucent. Turn the photocopy over and brush the mixture carefully onto the right side. Leave to soak for a few minutes. Choose a piece of fabric which has a smooth, closely woven surface – silk is probably the best, but satin, polycotton, polyester and organdie all work well. Calico and cotton will give a less well-defined print. Place the fabric on a hard, smooth surface and iron with a hot iron. Use a metal baking tray or an old dinner mat under the fabric as an ironing board (even a hard one) is not hard enough. While the fabric is still hot, place the wet photocopy on the fabric, right side down, and cover with a piece of clean plain paper. Make sure the iron is hot (cotton/linen setting); this may seem too hot for silk or polyester, but the fabric is covered with the plain paper so scorching should not occur. As white spirit is a flammable substance, you may wish to turn the iron off, just prior to ironing the print, as a safety precaution. Iron for approximately one minute, moving the iron slowly from side to side and using

hard, even pressure over the whole area of the design. The fumes from the heated white spirit are not very pleasant but they are short-lived and working in a well-ventilated room helps. Remove the paper and the photocopy from the fabric to reveal a perfectly transferred design.

If wording or letters are used in the design, have the print put onto acetate film, reverse the film, put white paper behind it and photocopy it again. You will then get a reverse copy which will be the right way round when printed onto the fabric. Only one print can be made from each photocopy. However the process of printing does not harm or lighten the print, so it is quite simple to photocopy the original again for subsequent prints of the same design.

Think of the potential of this technique. Anything that can be photocopied (remembering copyright regulations, of course) can be printed onto fabric – photocopied real flowers described earlier, the first drawings of a child, enlarged rubber stamp designs and, of course, anything from your sketchbook. Imagine the fun of sketching flowers or a little landscape on holiday, knowing that you can print them onto fabric. Select some areas of the design to be embroidered, leaving others unworked; this can give a feeling of depth and distance, with extra focus on the embroidery itself. Do not think of the print as a 'transfer' which has to

be covered with stitching, but as the delicate fine lines of the design drawn magically on the fabric. Colour photocopies, which are now more widely available, can also be transferred by this method, but they are still quite expensive.

Shadow work

Many of the stitching methods described so far in this chapter look completely different if worked on a sheer translucent fabric. Simple darning on organdie, for example, takes on a new dimension – the stitches on the back of the fabric show through to the front, as a paler version of the thread colour used. As in most shadow work, the only problem is the care that has to be taken in starting and finishing threads. This is achieved by darning into the threads on the back of the work, not into the fabric.

A variation of stitched shadow work is worked on two layers of fabric, a backing fabric of cotton or calico with a top layer of sheer fabric (organza, organdie, chiffon or a very fine silk). Pieces of coloured fabric are trapped between the two layers, appearing paler and shadowy under the translucent top layer. Fabric painting and stitching can be worked on the backing fabric before the top layer is added. Simple back or running stitch is then worked around the trapped fabric shapes, with additional stitching to complete the design.

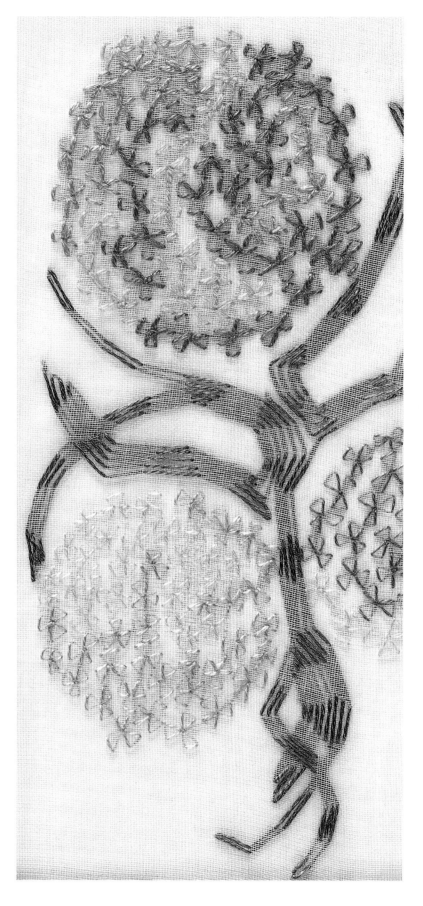

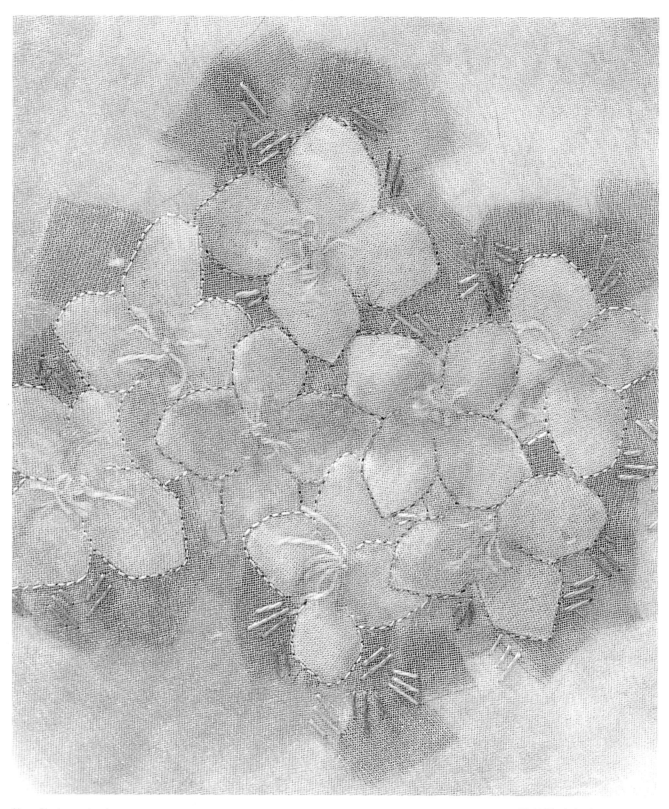

Above Shadow work using
white organza over painted
cotton with fragments of
organza, back stitching and
straight stitches
Marion Brookes

Right Rhododendrons
Painted on calico with fabric
paints and partially embroidered
in long and short stitch with silk
threads. Wrapped card to form
a mount
Evelyn Jennings

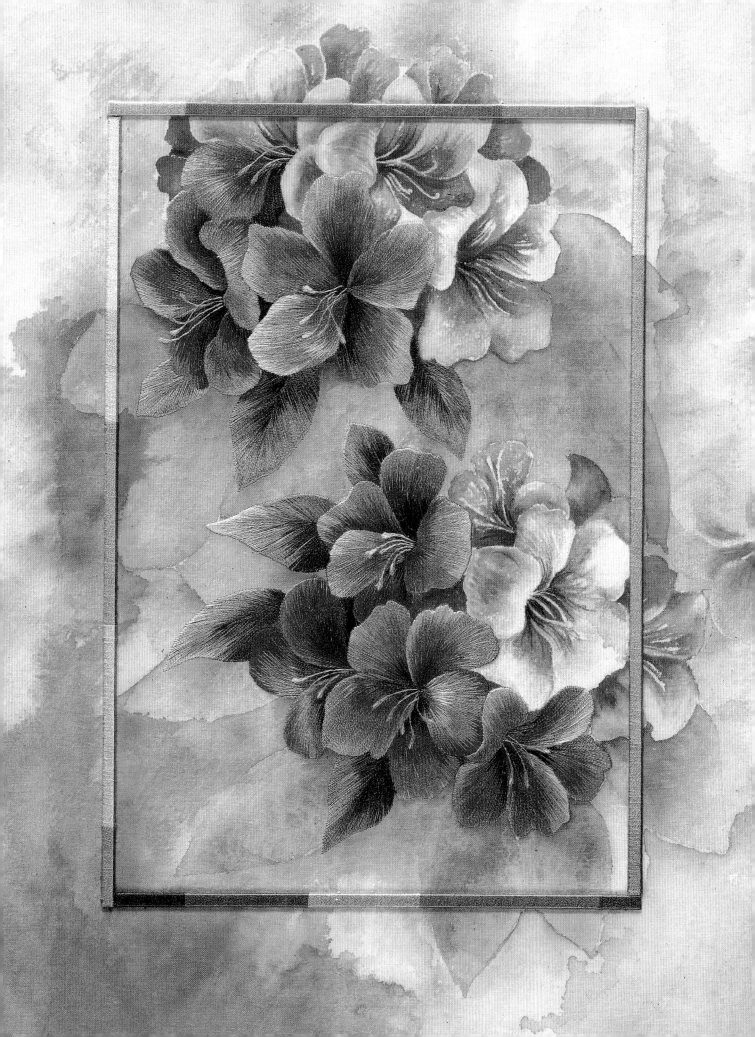

Appliqué & Quilting

Appliqué & Quilting

The popular technique of appliqué is very appropriate for the interpretation of flowers. In the natural garden setting we see flowers with their own background of leaves and foliage. The petals themselves are often overlapped or 'applied' onto each other, showing a delicate, papery translucency which all artists strive to depict. The embroiderer has a range of fabrics in different colours and textures; we can dye and paint fabrics with vein-like streaks and, best of all, we have sheer fabrics which mimic the petals to perfection.

Forget, for a while, any thoughts of turned-under edges and neat hemming. Nature gently rolls, curls, twists and flutes her petals. Let the fabrics do the work for you.

Above Simplified drawings of roses

Right A pattern of abstract flower shapes with stalks printed with the edge of a piece of card

Far right Poppies Applied fabrics including organza and silks on a painted background with added straight and fly stitches
Marion Brookes

Working with fabrics

Before you start collecting fabrics for appliqué, take time to study the colours in a flower. It is far too simple to say that sunflowers are yellow and poppies and red. Look at the buds, the full flower and the faded flowers, observing the subtle changes in tint, tone and shade. Are the leaves a blue-green or a yellow-green, pale or dark? Are they the fresh colour of spring or tinged with autumn? When you feel you have got to know the flowers, start collecting the fabrics together. Include your own painted and printed fabrics, and oddments and scraps left over from another project or the result of a printing workshop. You will need sheer and translucent fabrics and nets. Silk net is far more pleasing to work with

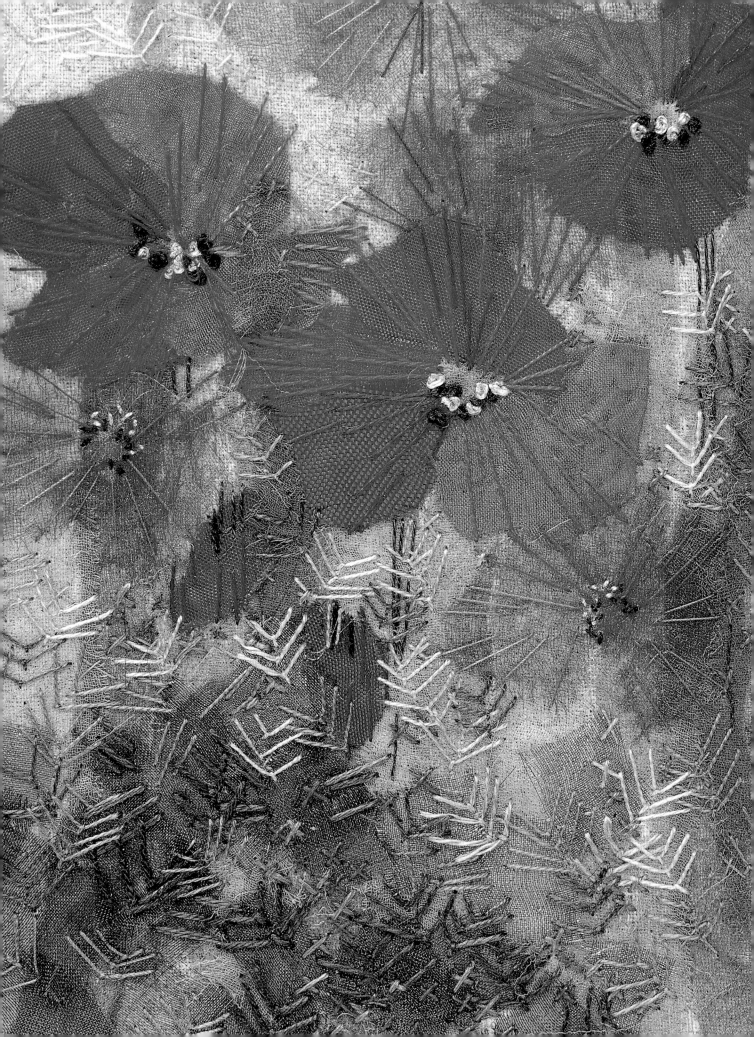

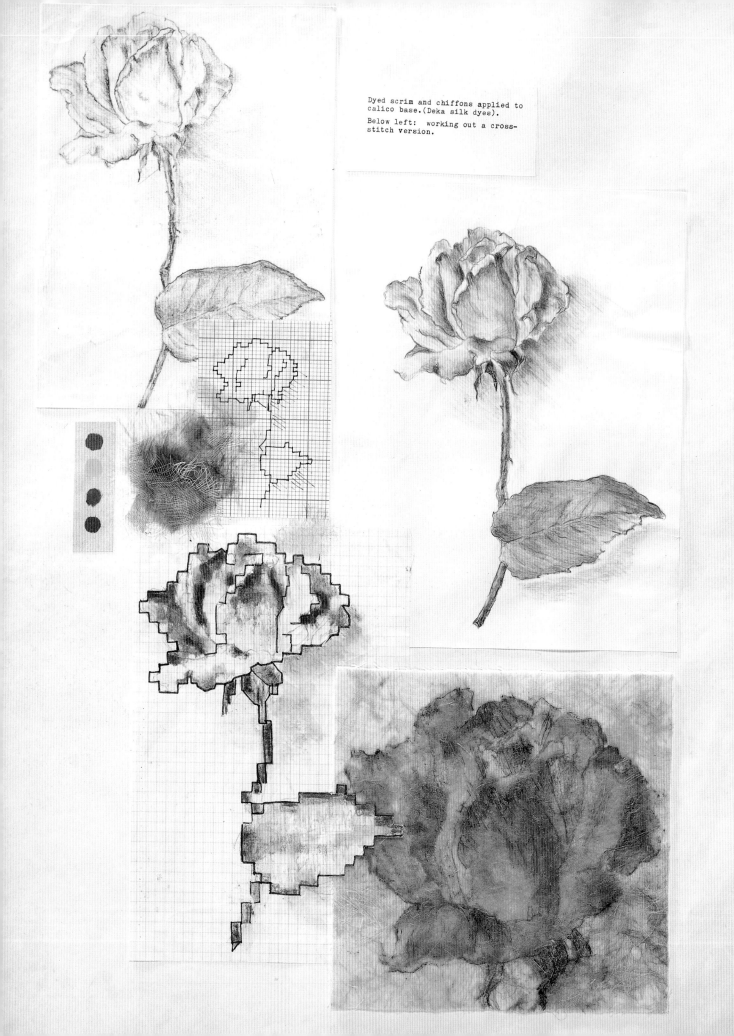

Dyed scrim and chiffons applied to
calico base.(Deka silk dyes).
Below left: working out a cross-
stitch version.

Far left Sketch book page
based on roses showing
adaptation for cross stitch.
Sample worked in dyed scrim
and chiffon on calico
Margaret Jones

Left Crayon and wash
flower studies
Margaret Jones

Below Layers of chiffon,
net and organza
Margaret Jones

than nylon net, which is harsh both in colour and texture, and will not tear easily. You may have to visit a bridal department or shop to obtain silk net; although it is more expensive, it takes dyes and paints very well and can be torn into soft shapes and strips. Keep looking at the drawings, the photographs and, wherever possible, the real flowers you wish to interpret. Separate the petals, noting their shape and how the flower is formed.

At this stage, you might want to make a template of the petal shape as a guide for cutting the fabrics. However, a spontaneous approach with scissors is fun and often mirrors the variations in nature rather better. Cut into two or three of the fabrics, making petal shapes, and lay these on the background fabric. Arrange and rearrange them, overlapping petal on petal, to

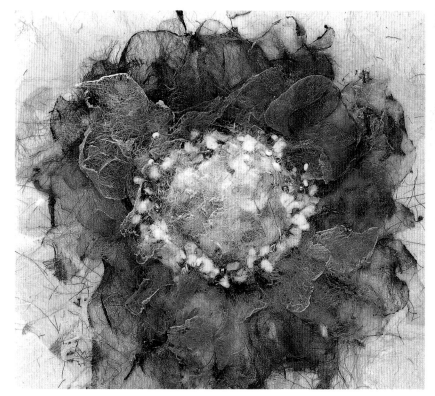

capture the nature of the flower. Add fragments of greenery, not necessarily perfect leaf shapes, and the odd fallen petal. A dab of craft glue or a few tacking stitches will keep the main or

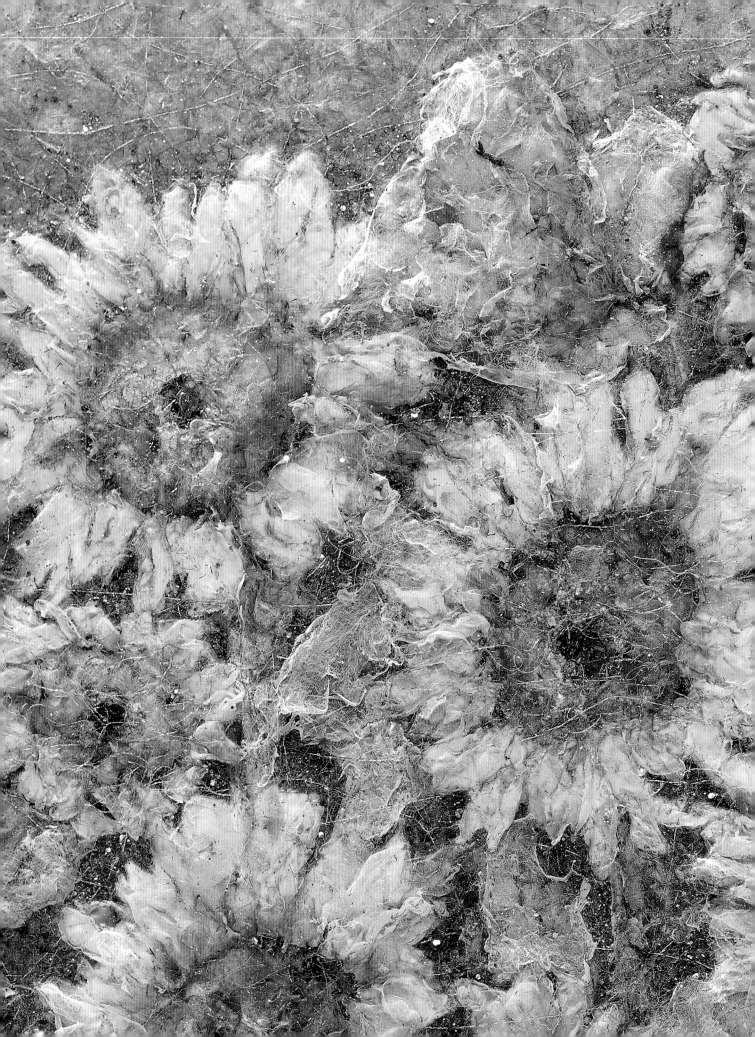

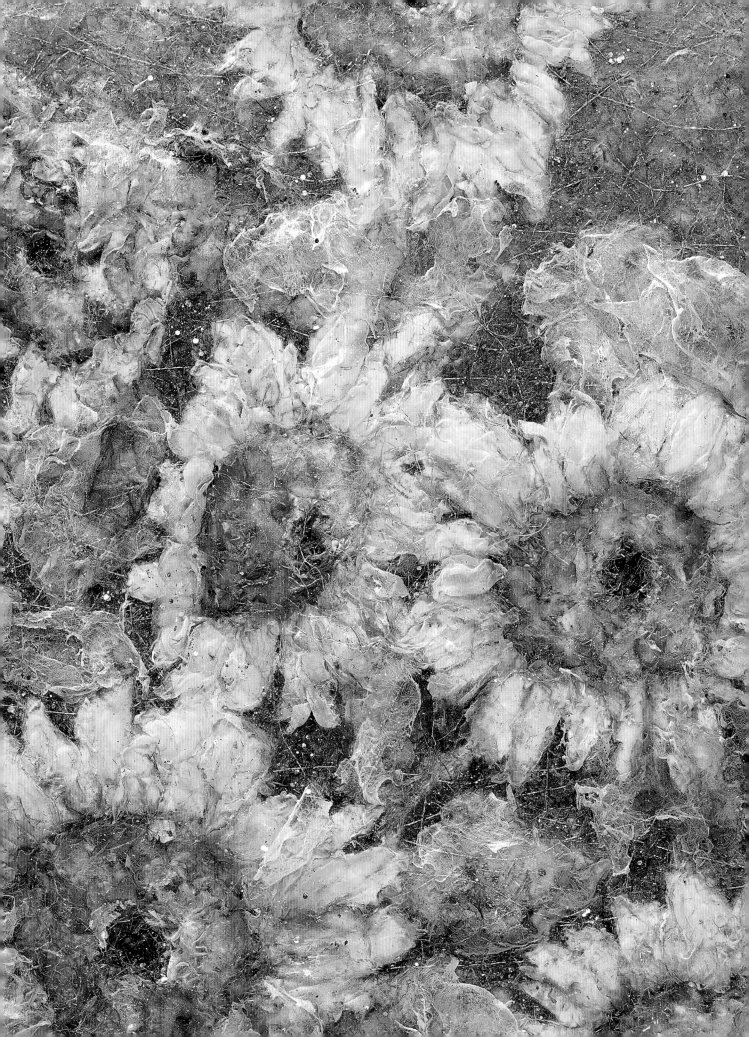

Top Embroidery from computer aided design of roses. Layers and torn strips of dyed silk net outlined with narrow free zig zag machine stitching and satin stitch blobs using metallic threads

Right Computer aided designs of an almost dead rose

Previous spread Sunflowers Raised areas of layered felt with applied translucent fabrics, manipulated to emphasize the flower forms. Embroidered with straight stitches and running stitch
Margaret Jones

larger pieces in place, preventing matters from getting out of hand. Add stitching, either by hand or machine, to secure the fabrics and to integrate the shapes with the background. Straight stitches, seeding, darning and short, broken lines of stitches such as cretan, buttonhole and fly stitch will all merge the flowers with their background, just as nature does. If you prefer to work by machine, use free running stitch to secure the main pieces. It may be difficult to frame the fabric, so use a darning foot and back the embroidery with felt for added stability. Free zigzag, perhaps using a shaded or variegated thread, can be worked around the applied pieces and onto the background, with hand stitches to add depth and focus in parts.

Always look carefully at the form of the flower and, in particular, at the edges of the petals, trying to recreate what you see. Many flowers have layer upon layer of delicately curled petals. This will determine how you apply the fabrics and how you stitch them. Let the fabrics stand free from the background with the petals just attached at their base, giving the ruched, layered feel of the flower itself.

Bonded appliqué

A more durable, functional appliqué is achieved by using Bondaweb. One side, the paper side, feels smooth; the other side, the layer of adhesive, feels rough. Iron the rough adhesive side onto the back of the fabric to be applied. If this is a sheer or fine fabric, it is advisable to pin a large piece of baking parchment (silicone paper) onto your ironing board first, otherwise some of the adhesive will seep through the fine fabric and your ironing-board cover will be forever sticky! Once the fabric is backed with Bondaweb, it is easy to cut out intricate petal and leaf shapes. This can be done freely, following a pencil line drawn on the paper backing or with the aid of a template. Next remove the paper backing from the fabric. It is sometimes fiddly to prise the paper away from the fabric, but

Right Layers of dyed silk, organdie and net on a painted silk background embroidered with French knots and cretan stitch

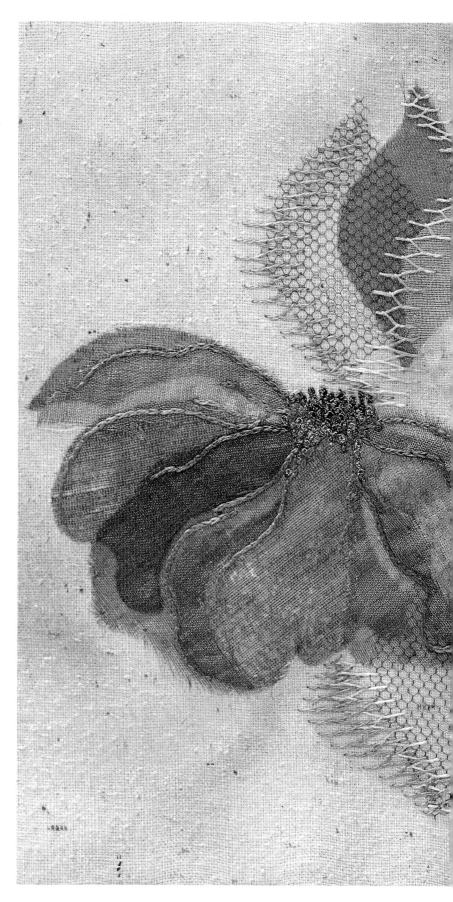

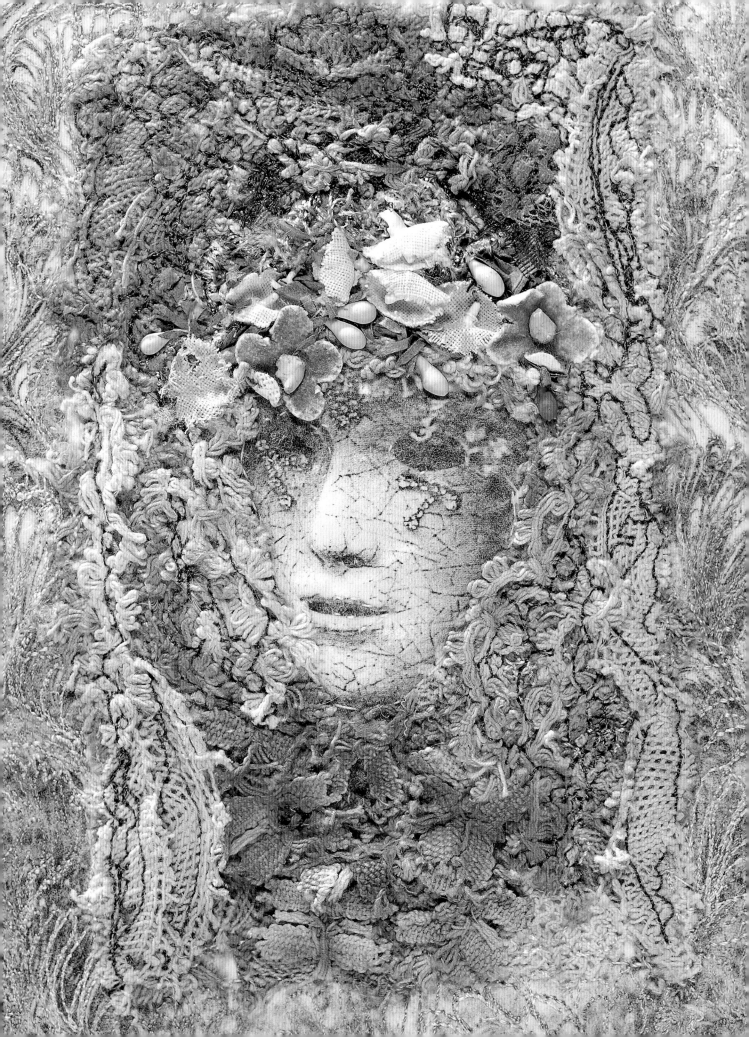

very easy if you put a pin into the fabric side and thus remove the fabric from the paper, not the paper from the fabric. Be very careful to lay these pieces of fabric adhesive side down onto the backing fabric before ironing them in place – many an embroiderer has placed a piece glue-side up, and then found it stuck firmly to the base of the iron. As a general rule when using Bondaweb, I use an old flat iron rather than a steam iron. The holes in a steam iron can adversely affect the adhering properties of the adhesive and, if the iron base does become sticky, it is far easier to clean a flat surface than poking about trying to get the steamholes clean.

Appliqué with Bondaweb eliminates the need for any conventional glue, pins or tacking and it prevents the edges of the applied pieces from fraying. However, it does slightly stiffen the fabric and this should be taken into account when planning the embroidery. Sometimes it can be a positive advantage, other times not so. Hand or machine stitching is worked as added security for the applied pieces, as well as to integrate them with the background. A finer than usual needle should be used for hand stitching as this seems to slip through the adhesive more easily. Conversely, use a heavier needle than normal for machine stitching – change it more often as the adhesive blunts the needle.

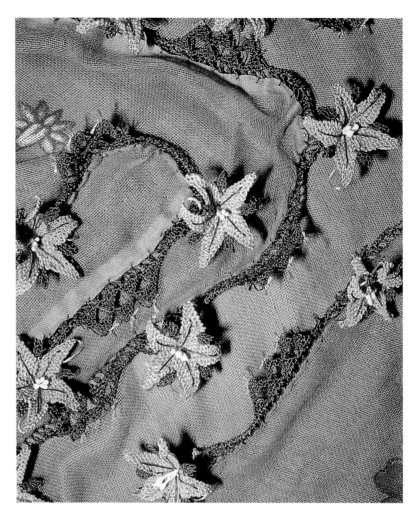

Burnt-edge appliqué

Another way of sealing the edges of a fabric likely to fray is to burn or singe it. In the right context this gives a most interesting, slightly uneven edge, but be sure it does not appear contrived or just an ill-conceived gimmick. Although a candle flame can be used, it is fiddly and potentially hazardous when you are dealing with small shapes. A far better method is to invest in a pyrography or poker pen or a soldering iron. Pyrography kits, sold in many craft shops, are used primarily for burning designs into wood and leather. They have a range of tip ends and

Above Turkish Oya Shawl Stiffened needle lace flowers on edges of fine cotton shawl printed with flowers and leaves and added needlepoint edging
Sheila Paine's collection

Far left Venetian Mask Photocopy of a face printed onto fabric with hand and machine embroidery and applied fragments of space-dyed textured fabrics
Della Barrow

decorative pattern tips. Alternatively, you may be lucky enough to find you already have a soldering iron in the garage. For successful results on fabric, however, check the wattage of either poker pen or soldering iron; it needs to be 22-25 watts to effectively burn or singe silk. In error, I purchased a soldering iron, a bargain offer in a DIY store and then found it was only 15 watts and would hardly singe anything! Incidentally, although we spend far too much time on the household ironing, many people do not know that the average iron is between 700-1000 watts.

Always work on a safe, protected surface when using a poker pen. Frame a fine fabric very tightly in a ring

Painted evenweave linen with applied dyed muslin and silk and textured fabric leaves. Hand stitches include French knots, padded straight stitches and detached chain
Marion Brookes

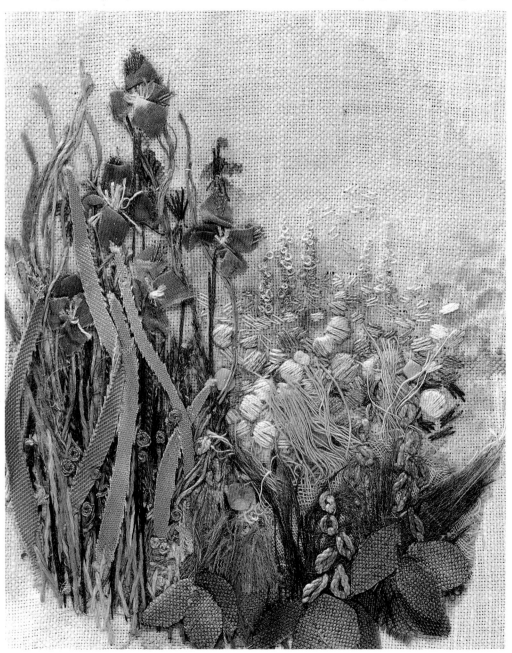

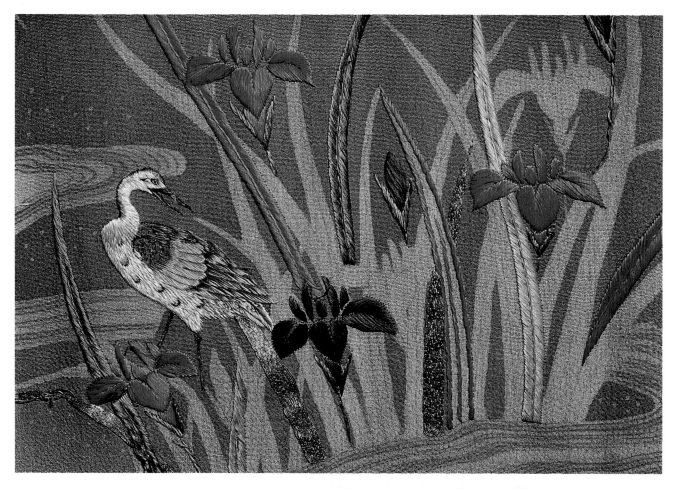

frame, placing it fabric uppermost as for hand stitching. Burn flower and petal shapes, drawing the fine tip of the poker pen slowly along pencil-drawn lines or freely, as you prefer. Even if the poker pen does not burn right through the fabric, you can then cut round the shape with sharp scissors within the thickness of the singed line. Always work in a well-ventilated room as some fabrics give off rather strange fumes. Be cautious when using man-made fabrics, trying a test piece before embarking on a large project. The application of a poker pen can result in a large hole in some fabrics and not the little petal you had hoped for!

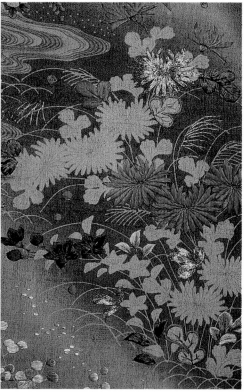

Above Japanese Kimono Detail showing iris flowers and exotic bird

Left Japanese Kimono Fabric printed with flowers, leaves and water wave patterns, embellished with satin stitch and metal thread *Sheila Paine's collection*

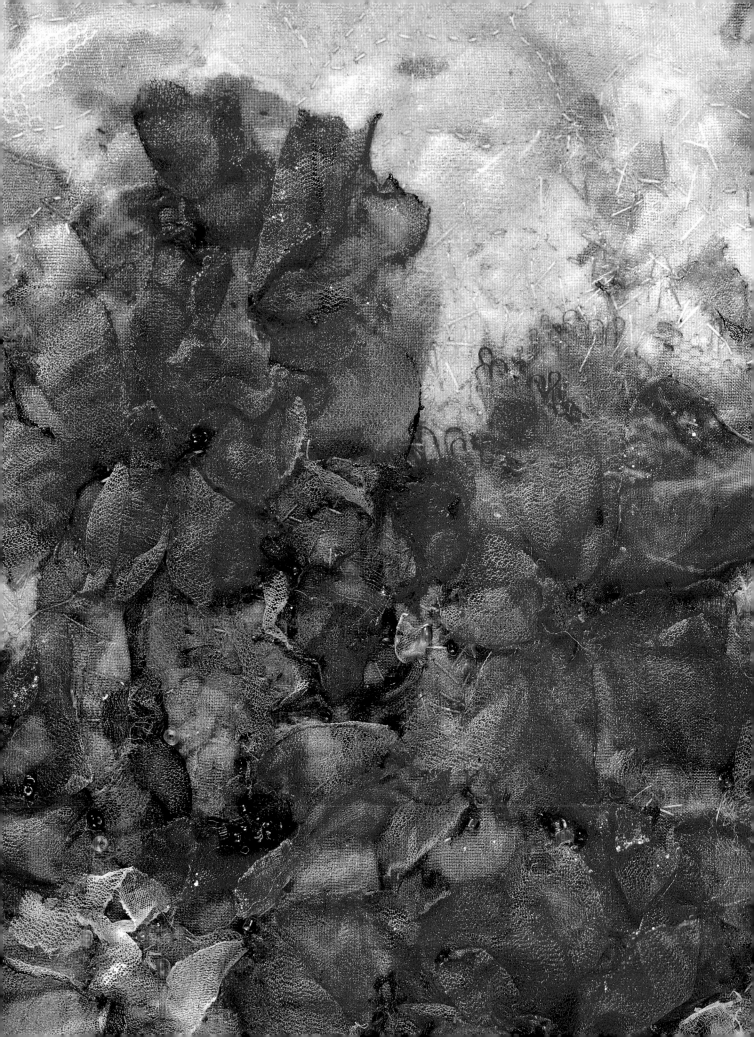

Burning and bonding

One of the easiest methods of appliqué is to combine Bondaweb with the use of a poker pen. Iron Bondaweb onto the back of a fine silk fabric. (It is especially effective if this has been sponged or printed with fabric dyes beforehand.) Place the fabric, paper-side down, onto a hard, heat-resistant surface. Draw slowly with the tip of the poker pen around flower or petal shapes. This will burn through the fabric, but not the paper backing. Lift a corner or tip of each fabric shape with a pin and remove it from the paper. Place it, adhesive-side down, onto the background fabric and arrange and rearrange until you are happy with the result. As there may be a touch of adhesive on the burnt edges, cover it with a piece of tissue paper or baking parchment before ironing in place. Flowers made in this way can be overlapped, ironed onto patterned or hand-made paper, over strips or fragments of torn net, and onto sheer or textured fabrics.

Poppies
Background of fragments
of fabric trapped behind
crystal organza with flowers
of various translucent fabrics
embroidered with French
knots, added stitchery
and beads
Margaret Jones

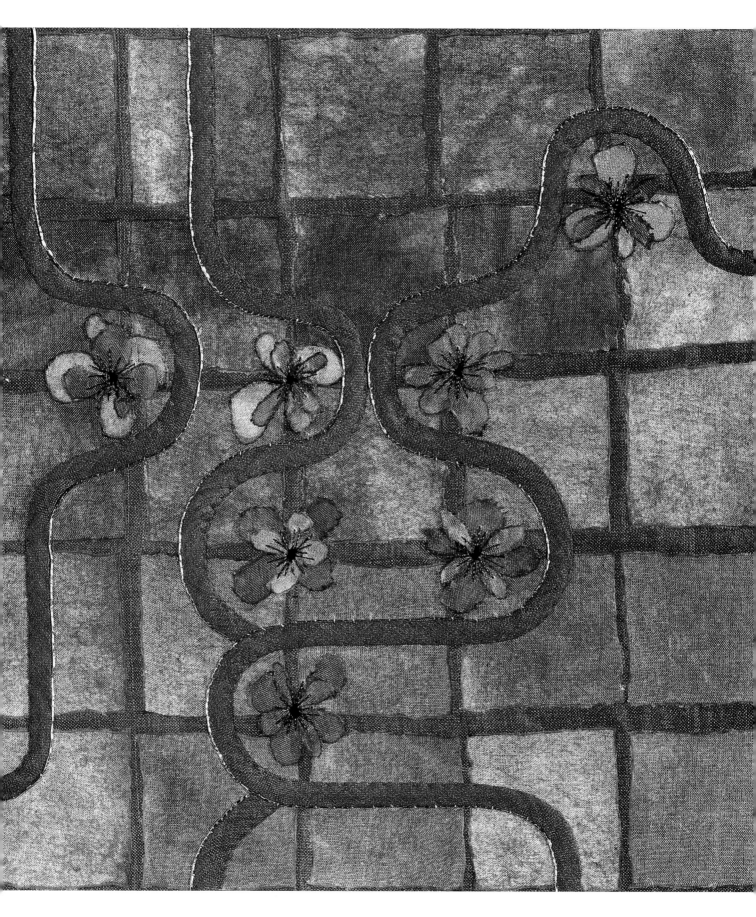

Cut-back appliqué

A variation of conventional appliqué is to layer together two or more pieces of fabric. Stitch the design onto the top fabric, through all layers. When complete, use very sharp fine scissors to cut through the top layer, as closely as possible to the lines of stitching, to reveal the fabric underneath. Hand, back stitch or running stitch can be used but machine stitching is more secure, giving a firmer line to cut against. Any fabrics can be used and the frayed, cut edges are an attractive element of the technique. Felt, on the other hand, does not fray and the round, slightly raised cut edges look equally attractive. If you are using more than two layers of fabric, each cut-out shape can go through as many or as few layers as you wish, exposing different colours in each area.

Italian quilting

There are many specialist books devoted to quilting techniques. Italian quilting is traditionally seen as monochromatic patterns of raised, padded lines, often in Celtic or inter-lacing designs. It is simpler and much more fun to cover the entire fabric with parallel lines of stitching, padding each channel with quilting wool to give a raised surface. A fabric made in this way has a lovely soft, pliable feel, more so than the all-over wadded English quilting – this makes it ideal for cushions, bags or fashion items.

Left Squares of space-dyed burnt edge silk bonded to silk fabric with bias strip appliqué, edged on one side with Jap gold. The flowers were cut out with a poker pen, bonded and secured with metal thread eyelets

Below Cut-back appliqué with painted and dyed felt over evenweave wool, machined with free running stitch and satin stitch, with the felt cut back in parts
Sally Brockbank

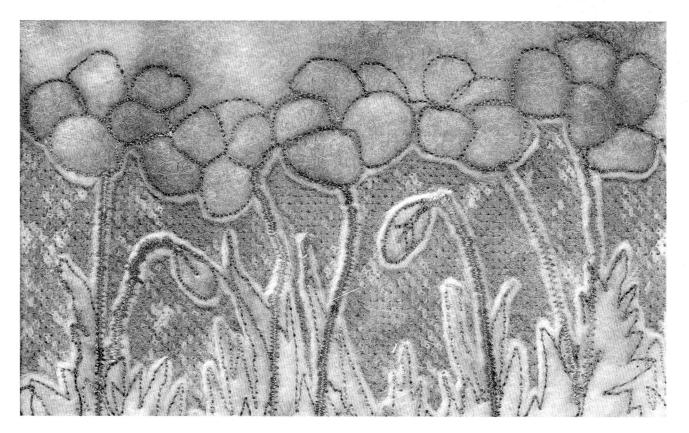

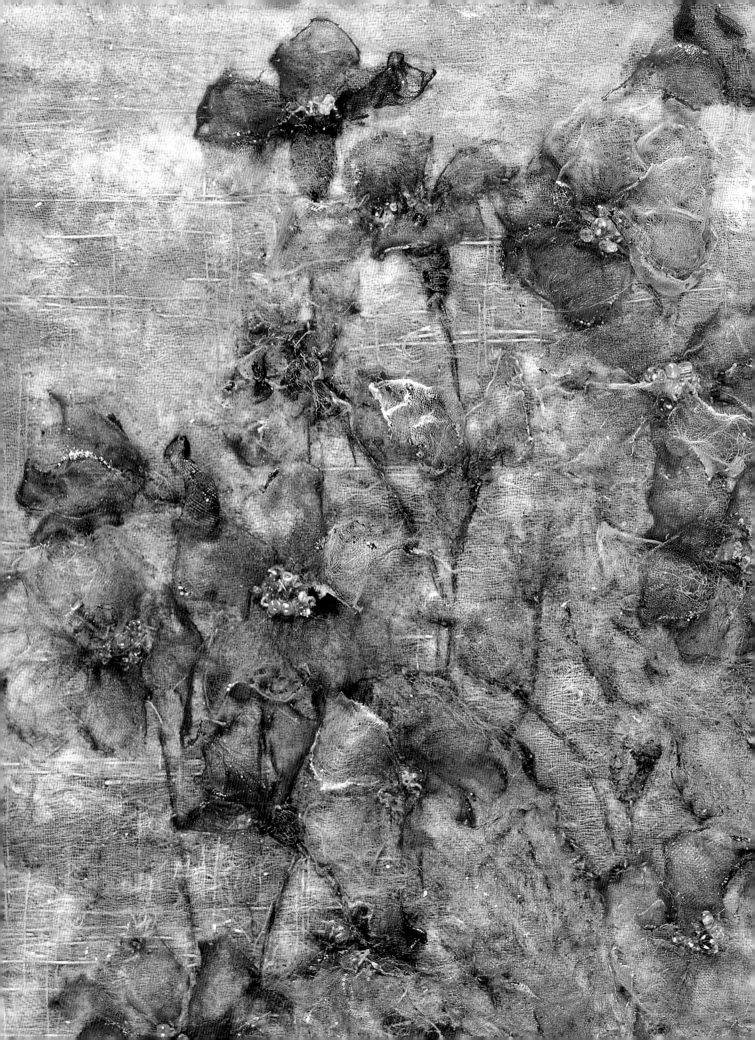

Back the fabric with cotton or calico. Many traditional sources recommend muslin as a backing for Italian quilting but, as muslin is softer than the top fabric, the padded effect seems to be more prominent on the back than the front. The use of a stronger fabric on the back will ensure that all the padding shows on the right side. Thread the machine with a colour to match the background fabric. Measure a central line from top to bottom, mark with pins then sew a tacked line. This will ensure that the first line of

stitching is straight. After that, use the previously sewn line and the width of the satin stitch machine foot to determine the placing of the next line. Stitch one line from top to bottom, followed by the next line from bottom to top, working from the centre of the fabric out to one side. Then continue from the centre to the other side in the same way. Stitching alternately from top and bottom will stop the fabric distorting. Additionally, the finished fabric will look more interesting if the spaces between the lines vary from

Above Rose design on layers of textured Japanese papers

Left Forget-Me-Nots Transfer dyed fabric behind a layer of chiffon with dyed chiffon used for the flowers and leaves. Embroidered with hand stitches and French knots in a variety of fine threads
Margaret Jones

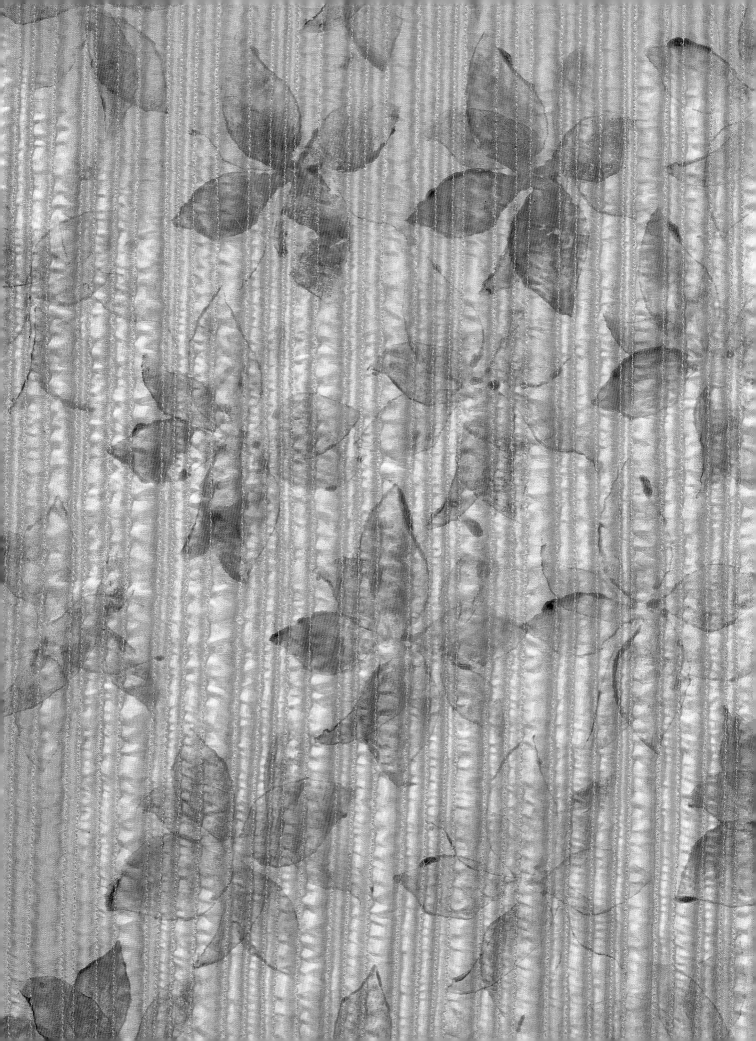

quite narrow to wide, working irregularly across the surface.

Quilting wool is obtained from specialist quilters' shops and larger department stores, but you can also use ordinary thick, soft wool. Find a range of blunt needles, from tapestry needles to bodkins. Thread the wool through the stitched channels one at a time, with one strand of wool in a tapestry needle for the narrowest channels, and several strands together in a bodkin for the wider channels. When all the channels have been padded, sew a line of machine stitching along both sides to secure the ends of the wool. Then cut away the excess ends of wool before making up the chosen item.

Potato prints

Before stitching the parallel lines of Italian quilting, you can pattern the fabric with potato printing. Although there are many more complex and sophisticated methods of printing, a potato is remarkably effective. Take a large, old potato and cut it cleanly into two halves. Lay one half, cut-side down, onto a sheet of paper. Draw round the potato with a pencil, then remove the potato. On this oval or circular shape, draw a four-petalled flower with the tips of the petals just touching the outer pencil line. Cut out the paper pattern of the flower and press it onto the cut, wet surface of the potato. Take a small, sharp craft knife

Left Potato printing on fine silk fabric with irregularly spaced parallel lines of Italian quilting

and cut into the potato along the edges of the paper pattern, holding the blade upright. Remove the paper and cut away the excess potato from around the flower, leaving it as a raised shape on the surface.

Choose a fine or medium-weight silk fabric, iron to remove creases and pin or tape onto a hard, smooth surface. To prepare the fabric paints, put two or three blobs of colour onto an old flat plate and add a little water to dilute. Dab the potato into this, moving it around to pick up a mixture of colours. Print by pressing the potato onto a spare piece of paper to begin with – this takes off any excess paint and is useful as a check to see if you are happy with the effect. An alternative method is to use a paint-brush to paint the surface of the potato before printing. Experiment with both techniques to see which you prefer. When satisfied, print onto the fabric. Then turn the potato a little to the left or right, and print again over the top of the first print. This gives a softer, multi-petalled flower. Continue to print all over the fabric, varying the spacing between flowers as

well as the density of colour in each print. It is an addictive technique, quite difficult to stop once you have started, and I have made plans to potato-print metres of fabric for my workroom curtains! When the fabric is dry, set the paint by ironing, following the manufacturer's instructions.

Slightly less practical variations of the above technique will spring to mind. After the fabric has been potato-printed, tear narrow strips of sheer fabric such as organza, net and muslin. Lay these over the background fabric, letting them overlap to build up interesting colour effects. You will undoubtedly have some 'trial' potato prints on spare pieces of the fabric. Cut these out with fine scissors and apply them over the torn strips. Work the lines of machine stitching through all layers, not forgetting the cotton backing fabric. When completed, thread thick wool through the channels as described. Parts of the applied flowers, those which have avoided the machine lines, will stand proud of the fabric, giving a lovely texture to the surface.

Right Potato printing on fine silk fabric, overlaid with torn strips of sheer fabrics and cut out, potato printed flowers with irregularly spaced parallel lines of Italian quilting

Above Rose designs from the sixteenth and seventeenth centuries.

Colour quilting

This is a variation of English hand quilting. The stitching itself is carried out quite traditionally, but the method of transferring the design to the fabric gives a hint or shadow of colour around the stitching. It is very relaxing and therapeutic to work and the simple cushions illustrated opposite show how effective it can be.

Plan your design, drawing it out on paper to the full size of the cushion. You can also work with individual motifs, perhaps varying the sizes, and arranging them as you wish. Choose a medium-weight silk fabric, iron to remove any creases and pin or tape onto a hard, smooth surface. How to transfer an intricate design onto fabric for quilting often causes confusion but this is not the case with my method. You will need your paper design, a red biro and some fabric transfer crayons.

There are several makes available and some are more suitable than others. Look for soft wax crayons containing fabric dye pigment with a paper covering for ease of use. Turn your design over and draw a pencil line just beyond the outer edges of the image to be transferred – holding the paper up to the light will show this more clearly. Then colour within the pencil line on the back of the design, with the skill of a three-year-old! Make sure all the white paper is covered with areas of several different colours. Avoid blobs of wax by rubbing into them with your finger so that the coloured surface is smooth. Turn the design over and place it, coloured-side down, onto the fabric. Pin in position. Take a red biro and carefully draw over all the lines of the design. If you use a blue or black biro, it is extremely difficult to see which lines you have drawn over and which not. Remove the paper to reveal a perfectly transferred design in all its detail. It may look a bit too colourful at this stage but the stitching will cover much of the lines. Heat-set the transfer crayons by covering the fabric with tissue paper and ironing according to manufacturer's instructions.

Left Partly worked design of a Tudor rose printed on to silk fabric with transfer crayons, showing the coloured crayoning on the back of the paper and the transfer crayons

Take a piece of cotton or calico, cover with a layer of 50 g (2 oz) quilting wadding (batting) and lay the silk fabric on top. Tack the three layers together in both directions, with the lines approximately 7.5cm (3 in) apart. A square or round ring frame should be used to keep the stitch tension even. Work back stitch along the coloured lines, using a silk twist thread in a colour to match the silk fabric. Add French knots or eyelets as the design demands. The stitching sinks into the fabric, with just a hint of the transfer crayon colours showing at each side of the line. This is a very useful method of transferring a design and would work equally well with machine stitching. Think about leaving part of the design unstitched as the multi-coloured lines are attractive in their own right, adding to the overall effect of the embroidery.

Left Simplified Tudor rose motifs suitable for quilting

Below Two quilted silk cushions with the designs of Tudor roses printed with multi-coloured transfer crayons

Far right Heuchera leaves printed onto silk fabric with transfer crayons, quilted with silk twist thread and added eyelets

Right Photocopied skeleton ivy leaves showing the vein patterns

Leaf prints

On occasions it makes a change to feature the leaves of a plant, with just an indication of the flowers. The fabric transfer crayons described already can be used to print directly from a leaf onto the fabric, capturing every vein and marking on the leaf surface. Choose a fairly small leaf, feeling it between your fingers to check that it has well-defined veins (usually on the underside). Lay the leaf on a flat surface, vein-side uppermost. Take a transfer crayon and gently stroke the colour onto the whole leaf surface. Use one colour, or a combination of two or three colours merged together for an autumnal effect. Occasionally the leaf may tear, maybe due to the variety of leaf selected or because it is too young and immature. But nature is bountiful and there are many more leaves for you to experiment with. Heuchera is a particular favourite with its pretty rounded leaves, and geraniums and ivy work well too. When the leaf has been coloured, lay it, coloured-side down, onto the fabric. Cover with a piece of tissue paper and iron with a medium-hot iron. Remove the tissue paper and the leaf. Add more printed leaves to complete the design. Quilting is an ideal technique for the embroidery, either outlining the leaves or working lines of back stitch on the veins; complete with drifts of little eyelets to represent the flowers.

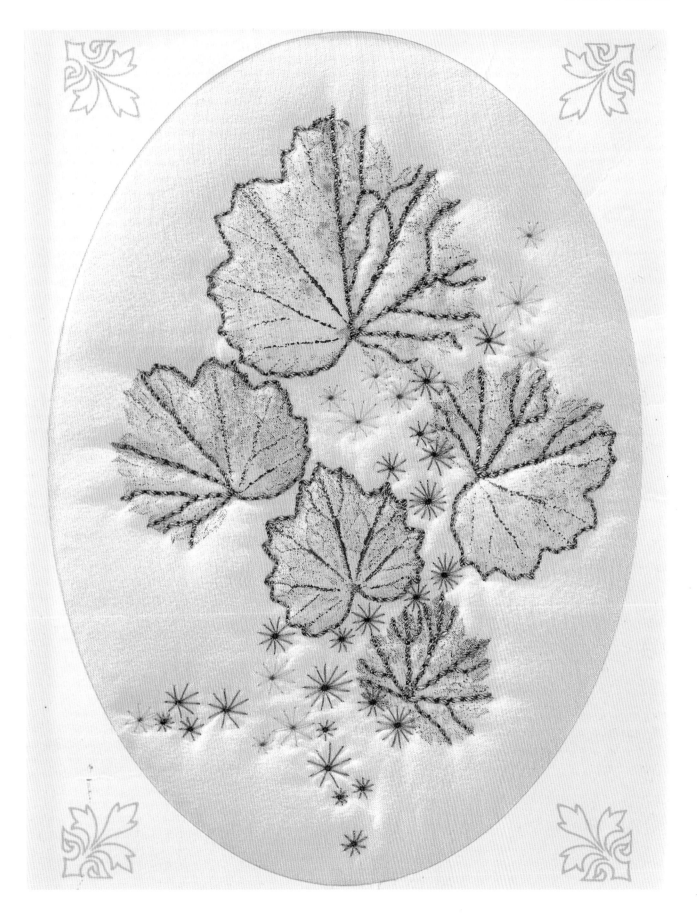

Cross Stitch
& Canvas Work

Cross Stitch & Canvas Work

Many embroiderers are familiar with counted thread cross-stitch designs, depicting formal and geometric representations of flowers, but this stitch can also be used as a much freer technique, giving greater scope for individual style. Cross stitch is traditionally worked on evenweave linen fabric but random cross stitching can be worked on a wide variety of fabrics. Printing the fabric can, again, be an excellent starting point. Try sponging or brushing colour onto calico through an open canvas or net mesh. Many of the nets sold for curtaining are ideal, either regular grids or with patterned or distorted meshes. This gives an indication of colour and a guideline for the stitching, albeit more random than the counted thread variety. Try a variegated thread, or two different-coloured thin threads used together in the needle, for a dappled and shaded background with a pattern of printed flower shapes.

Right Hydrangea flowers on printed calico with the negative shapes worked in free cross stitch using two differently coloured threads in the needle in some places
Marion Brookes

Cross stitch

Cross stitch can also be worked as a textured stitch, as described in Chapter Two. Work tiny little crosses in a fine thread, piled one on top of another, looking for all the world like a tumbling profusion of summer blooms. If you use a soft, matt thread, the crosses will appear to sink into the fabric, whilst with a shiny, twisted or man-made thread, the texture will be much more raised. Instead of thick threads, try cutting or tearing thin strips of fabric to stitch with. Some of the small flower-patterned fabrics usually intended for patchwork look very interesting used in this way. The pattern is diffused, resulting in little specks of bright colour intermingled in texture.

One of the rules of traditional stitching is that the top stitch of each cross should slant in the same direction. However free and random the stitching, this is still a good policy to follow, giving a pleasing flow to both the working of the stitches and the final appearance. As well as the

usual slanting St Andrew's cross, experiment with an upright or Greek cross. A look at any embroidery stitch book will give ideas for other cross stitch variations, often included under canvas work. Try long-armed cross, Italian cross, Maltese cross, knotted cross stitch, interlaced cross and wrapped cross. Wrapped cross is a normal diagonal cross but both 'arms' are wrapped tightly with thread to resemble bullion knots. Some of these heavier crosses can be worked as the dominant focal point in a design, supported by and surrounded with the smaller, more usual cross stitches.

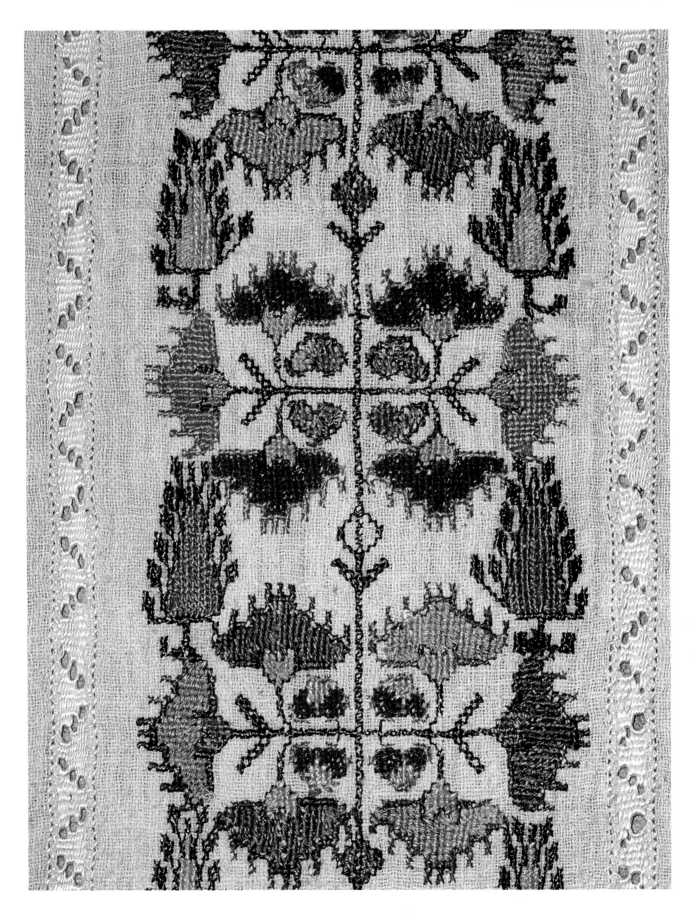

Canvas work

Similar traditions are associated with canvas work. Functional pieces such as chair seats and church kneelers do require a hard-wearing, flat surface of stitching which covers all the canvas. This type of work is therapeutic and relaxing to stitch. However, when it is possible to stretch and break these traditions, canvas work becomes a very exciting and creative form of embroidery.

Canvas is available from larger department stores and specialist embroidery suppliers in several different types. The main requirement for free stitching is that the canvas should be single mesh and not double or Penelope weave, which is mainly reserved for tent stitch. Many embroiderers like the expensive German brown canvas, which is easy to work on and has excellent hard-wearing qualities, but for an experimental approach the white canvas has far more possibilities. It should be available in various mesh sizes, the most usual being 10, 12, 14, 16 or 18 threads to 2.5 cm (1 in), as well as rug canvas which has 3 or 4 threads to 2.5 cm (1 in). On larger-hole canvas, i.e. 10 threads, the work is quick and easy but rather coarse compared with the finer canvas. The choice depends on what is available, the intricacies of the design and, to an extent, on eyesight!

Colouring the background

In a purely decorative piece of canvas work, it is not necessary to completely cover the canvas. Leaving part of it unstitched, or stitched lightly with a very thin thread, can imply depth and give more emphasis to the stitched areas. However, for the canvas to appear integrated it should be coloured before you start to stitch.

Pin the canvas onto a board, making sure that the sides are at right angles to each other. Sponge fabric dyes onto the canvas, merging several colours together to give an impression of greenery and flower colours. Try not to over-wet the canvas as this will loosen the size or dressing which secures the vertical and horizontal threads. (Some canvas is sold as 'interlocked' and the vertical and horizontal threads cannot be dislodged by wetting.) Leave the canvas pinned to the board to dry completely. Spray paint, available in aerosol cans, can be used successfully on canvas, but be sure to protect surrounding surfaces from accidents and work in a well-ventilated room.

Another method of adding colour to the canvas before stitching is to apply fragments of sheer fabrics such as organza, organdie, chiffon and nets. Nylon net, described in Chapter Three, comes into its own here. Cut small pieces of net and place them on the canvas, overlapping different colours.

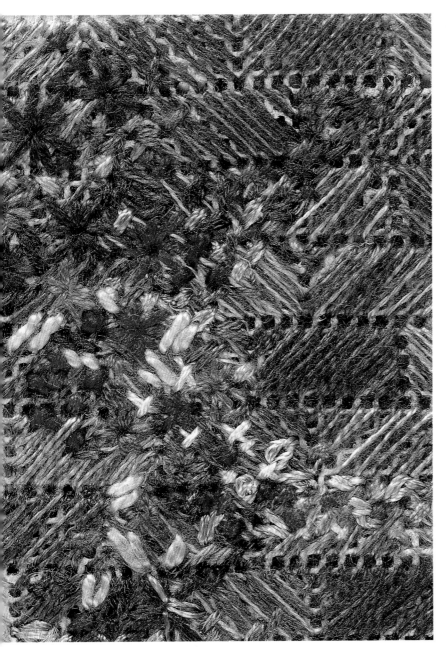

The hexagonal mesh of the net seems to blend and merge with the square mesh of the canvas to perfection, and is very easy to stitch through with a tapestry needle. With closely woven sheer fabrics you will need to use a sharp pointed needle for the stitching instead of the customary blunt tapestry needle. This makes it a little more difficult to keep the stitches regular, especially on a coarse canvas. Cut, torn and frayed pieces of fabric and net, applied to a canvas which has been coloured with fabric dyes, will give an excellent start to any project.

Stitches

The variety of different canvas work stitches could, and does, fill many a specialist book and all embroiderers who work on canvas have their own familiar and favourite stitches. Working freely and experimentally does not mean stitching incorrectly; indeed, it is far better to know a stitch well and then sensitively adapt it – omitting parts of it, working other parts double, making it smaller or larger – as required by the design.

It is very effective to stitch with a thin thread, on coloured canvas, giving a soft, delicate impression of foliage in the background. A thin shaded or variegated thread will give a similar effect.

As canvas is firm and strong, more so than fabric, it is particularly suitable

Above Blocks of diagonal satin stitch using two differently coloured threads in the needle with eyelets and cross stitch
Marion Brookes

Right Pattern for canvas work flower garden on page 93

for dense, textured stitching using thick threads such as raffia, ribbon yarn and thin ribbons, which would distort a fine fabric. Add French knots, eyelets, bullion knots and woven picots to your repertoire of plant and garden stitches. Looking through canvas work books, there are many stitches named after plants and it would be fun to work them. Try leaf stitch, petal stitch, rose stitch, rose overlapped stitch, fern stitch, flower stitch and floral stitch – perhaps forgetting beetle stitch and caterpillar stitch! Other stitches, such as smyrna cross, Greek cross, eyelets and rice stitch variations look remarkably like flowers. These simple stitches usually offer more scope for adaptation than the more complex stitches.

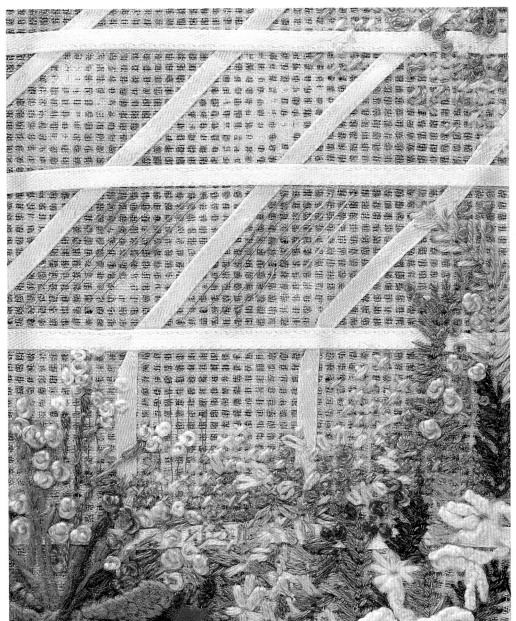

Left Organza and ribbons applied to painted white canvas with hand stitching including French knots, free cross stitch, woven picots and detached buttonhole bars
Marion Brookes

Overleaf Worked on painted white canvas with a border of satin stitch squares. The garden is worked freely using thin and thick threads with tent stitch, crossed stitches, French knots and needle woven picots
Marion Brookes

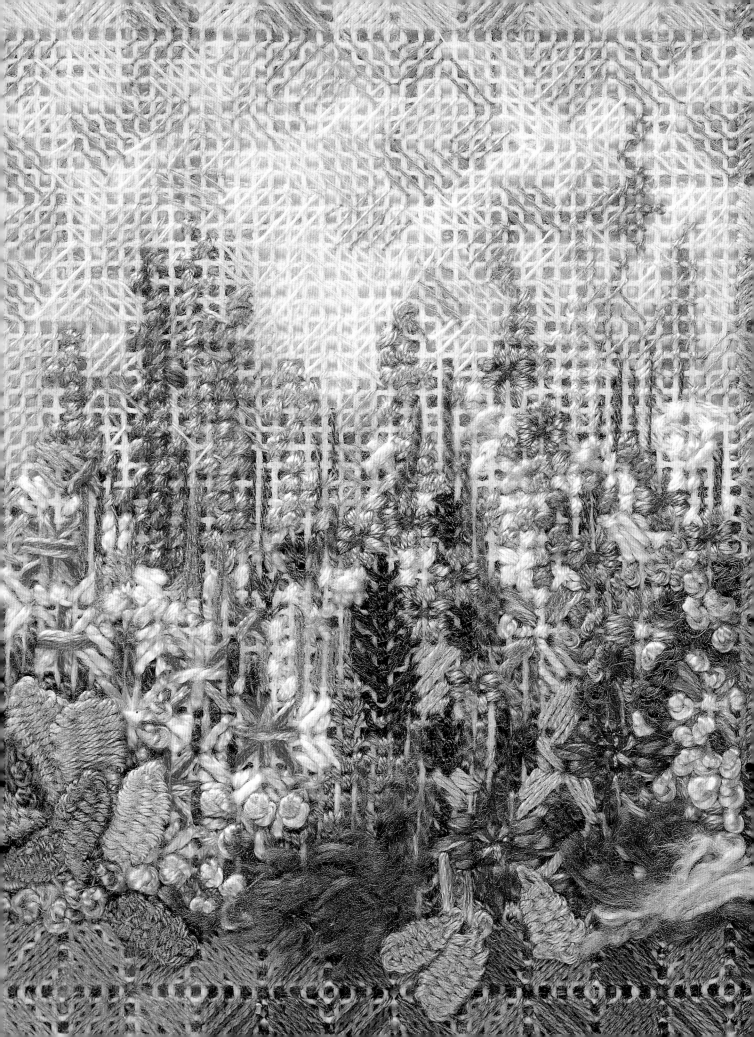

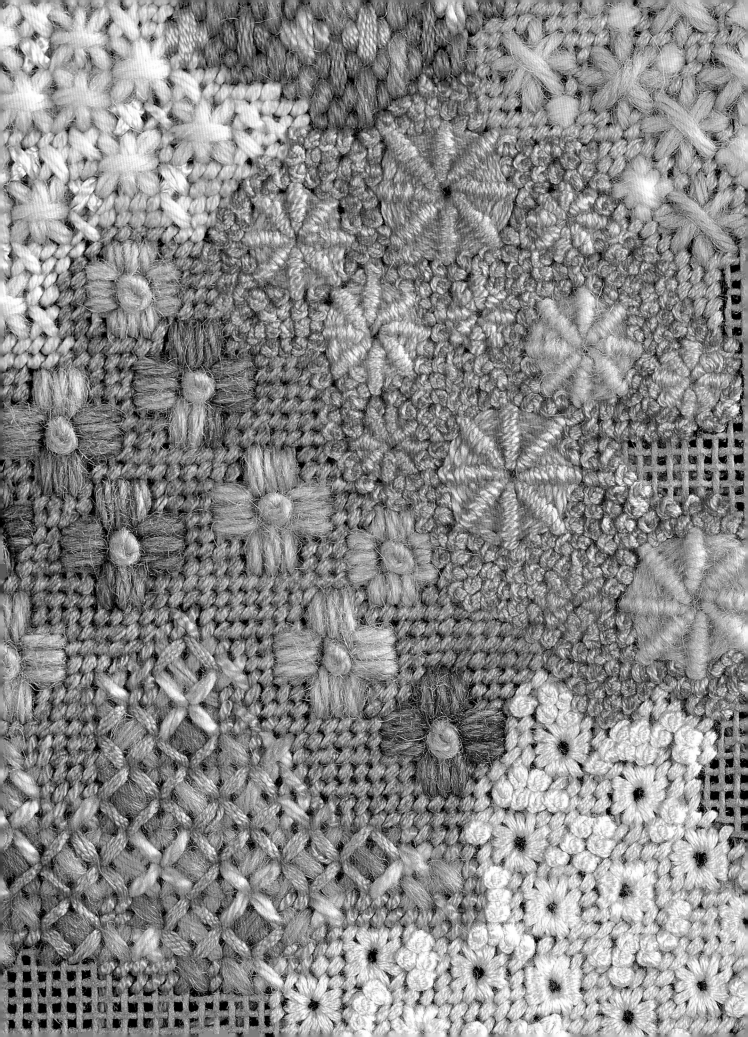

Machining on canvas

Fine nylon canvas makes an ideal background for machining. It is strong enough to take dense stitching without puckering or distortion, and the mesh is fine enough for a machine needle to pierce it. Set your machine for zigzag with a wide stitch width. Lower the feed dog or teeth and replace the ordinary foot with a darning foot. Practise lines of stitching, vertically and horizontally, on the canvas, letting the lines wander slightly from the true lines of the mesh. A grid pattern, however irregular, is a reassuring start. Thread the machine with a variegated thread and work a little four-petalled flower in each section of the grid. The zigzag stitching covers the canvas quickly and each flower will be slightly different.

Knot gardens

The geometric nature of knot garden design is ideally suited to the technique of canvas work, giving a more structured approach to the stitching yet plenty of scope for individual interpretation. The knot garden was at the height of popularity in Tudor and Elizabethan England. The Elizabethans surrounded themselves with fine textile hangings and embroidery, and their elegant country houses boasted elaborate and intricate gardens. The knot garden was situated near the house, to be viewed from the principal windows, and it became an extension to the

Previous spread, right Work in progress showing irregular shaped areas of stitching on single mesh brown canvas including woven wheels, eyelets, tent, straight and crossed stitches

Left Machining on painted white fine mesh canvas with a grid and flowers in free straight stitch and zigzag

95

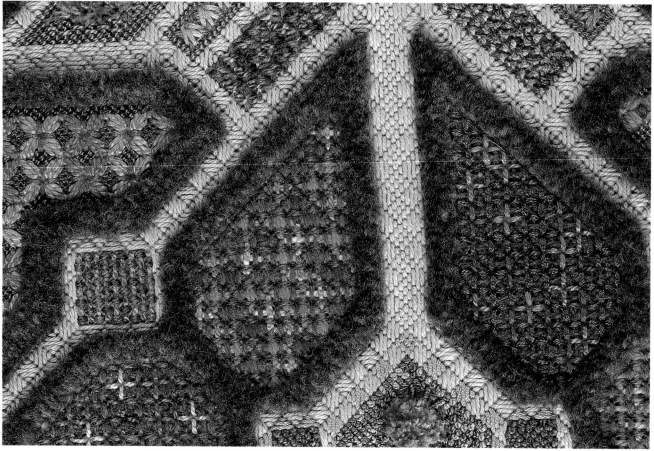

Above Detail of large octagonal Knot Garden showing clipped hedges in ghiordes knot stitch, paths, gravel and flower beds in a rice stitch variation

owner's lifestyle in much the same way as the garden room or patio are to the modern house. The love of intricacy was evident in the design of the garden, with a geometric pattern of flower and herb beds edged by a low evergreen shrub such as lavender, rosemary or box with a central feature of a pond or sundial. Although the knot garden was intended to be ornamental, it also provided flowers for nosegays and herbs for culinary and medicinal purposes.

Many great houses, both here and abroad, still have knot gardens or are in the process of restoring and rebuilding them. Drawings, photographs and garden design books will provide the initial inspiration. Rather than spending

a great deal of time transferring your ideas to graph paper, try cutting paper shapes for the main features and the flower and herb beds. These shapes can be placed directly on the canvas, allowing space between for paths and hedges. You will undoubtedly find that alterations need to be made to the design as work progresses, in much the same way as a real garden evolves.

Start stitching in the centre of the design at the focal point – a pond, ornamental urn or sundial. Rings or washers covered with detached buttonhole stitch make delightful tubs. Woven wheels, although time-consuming to work, add a strong focal point to the centre. French knots,

worked with several different colours in the needle together, make realistic gravel. Low hedges are worked in ghiordes knot, also known as single knot stitch in some canvas work stitch books. This gives a very upright narrow band of tufting clipped to shape; where the design requires a curve, it is more easily achieved with tufting than with most other canvas work stitches. Try working the hedges with two strands of crewel wool in slightly different shades in the needle together, to give a dappled effect; if the colour contrast is too great, however, the hedge will look distinctly unwell. Strive to achieve the same subtlety in the colours of the flower and herb beds, avoiding the temptation to work each bed in a different colour and

a different stitch. This would result in a stitch sampler and not a garden of flowers. Composite canvas work stitches (including double upright cross, web, rice, smyrna cross, looped half cross and hound's tooth cross) can all be worked first as a base in mixed greens, using different shades together in the needle or a shaded thread. Add tints, tones and shades of the flower colour for the second stage of the stitch, aiming to scatter the blooms as Nature does, rather than in geometric patterns.

Working on canvas is very therapeutic and knot gardens are addictive. On a cold day what could be better than planning, designing and working your garden in the comfort of an armchair?

Below Stitch samples on single mesh brown canvas. On the left there are variations on rice stitch worked in different sizes and on the right, floral stitch worked in metallic machine embroidery threads

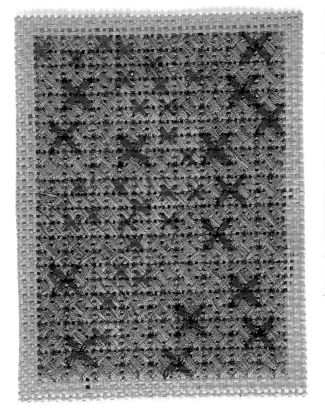

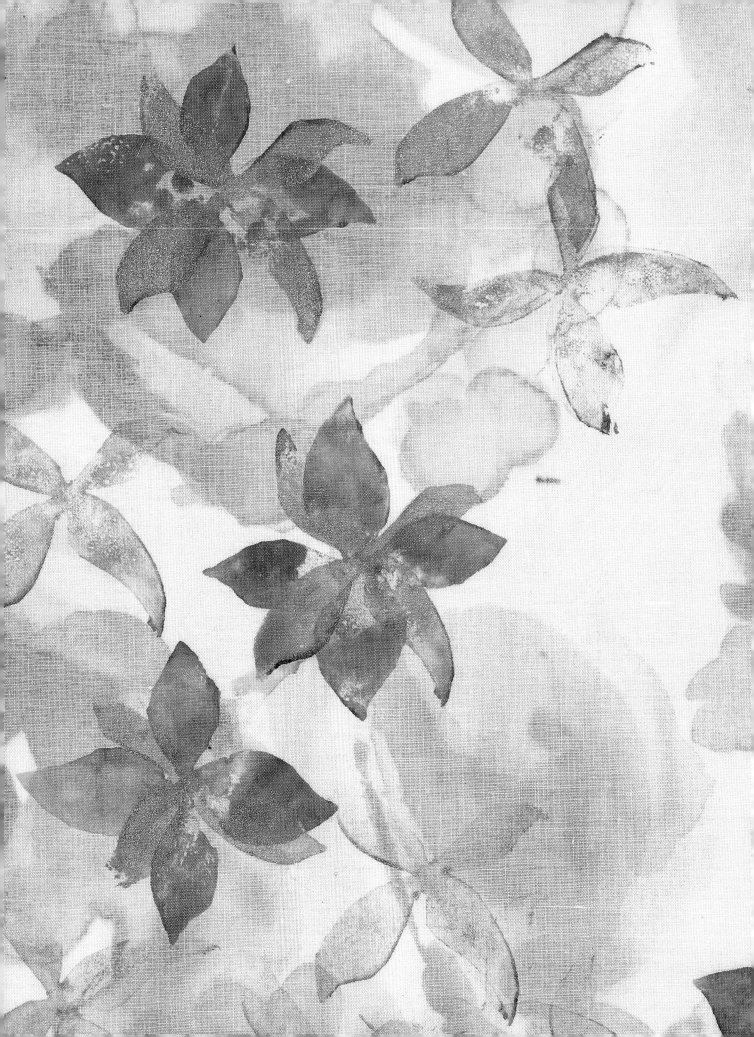

chapter five

Machine
Embroidery

Machine Embroidery

The most exciting aspect of this embroidery technique is its versatility. The machine will stitch the finest of lines, which sink into the fabric and almost become part of it. Delicate lace-like effects contrast with rich textures built up using whip stitch or massed lines of dense stitching which completely obscure the fabric. Add zigzag and satin stitch, loops, couching, wrapped cords and a wide range of textured and metallic threads, and it is almost impossible to think of a design that cannot be stitched with the machine. Many people still think that machine embroidery is the range of automatic patterns found on the latest high-tech computerized machines but, with just a little practice, the vast majority of electric machines are capable of working free machine embroidery and producing exciting and creative work.

Above Art nouveau rose typical of the Glasgow School

Right Art nouveau rose panel worked in machine chain stitch and cut work on black muslin

Machine embroidery

The main requirements to ensure success are that the machine is clean, warm, oiled and in good working order. Machines are surprisingly tolerant when used for ordinary household sewing and will carry on stitching in spite of loose bits of thread in the race and a blunt needle. These conditions, and any minor mechanical faults, will however, definitely cause problems when you are using the machine for free embroidery. Before you start any project, give your machine a thorough clean and check-up – it really is time well spent.

Most manuals do not include instructions for free stitching; embroidery is usually referred to in terms of the automatic patterns and, at best, instructions for free stitching are limited to practical darning. Preparing your machine for free embroidery is quite simple and will soon become second nature. Lower or cover the feed dog or teeth. Remove the presser foot, replacing it with a darning foot if your machine is supplied with one. Many experienced machine embroiderers prefer to work with no foot at all, but if you are a beginner, a darning foot

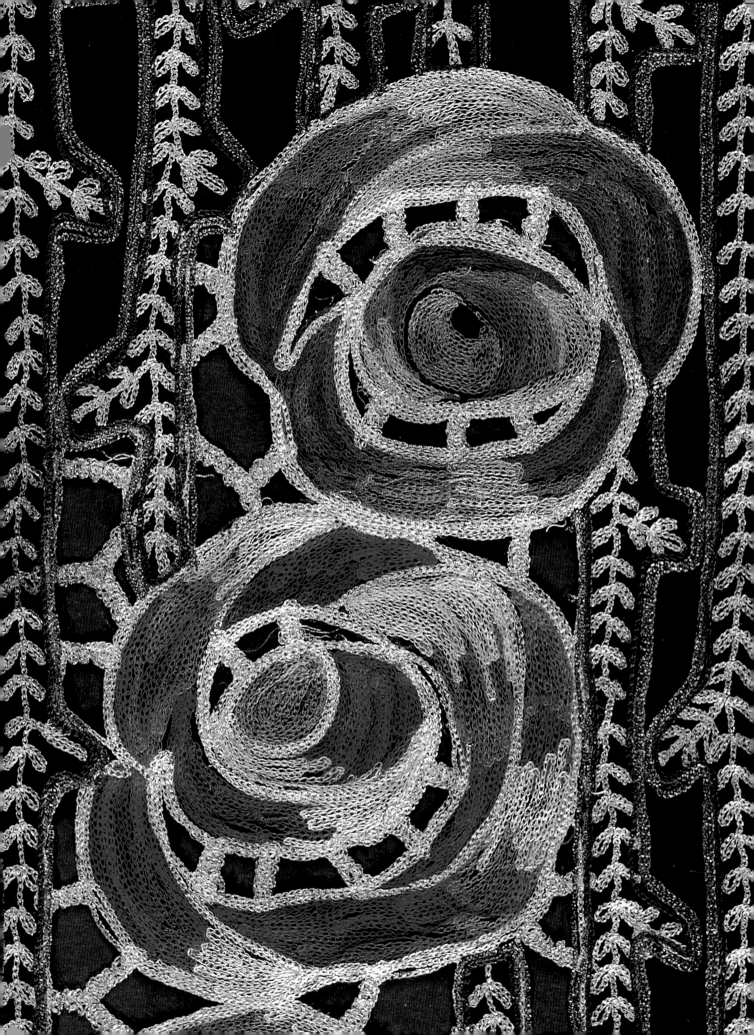

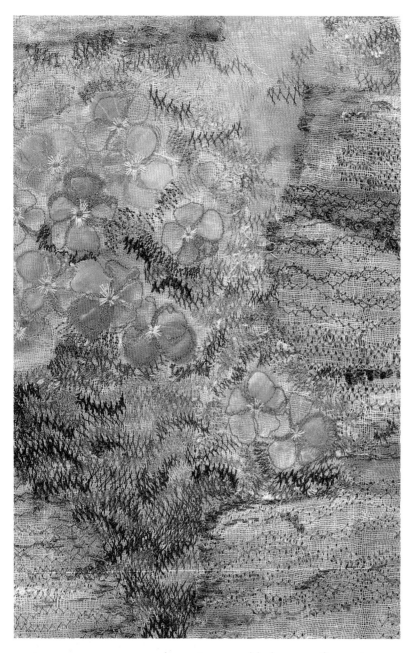

Above Detail of Rose Wall
Marion Brookes

Right Rose Wall
Background of muslin sponged
with fabric paint, partly
padded, with applied flowers
and leaves. Hand stitching and
free zigzag machining
Marion Brookes

preferably with some added fabric printing to give a reassuring start for your first attempts. Frame the fabric very tightly in a ring frame. A narrow wooden frame, approximately 18-20 cm (7-8 in) in diameter is suitable but many people prefer the metal spring ring frames for their speed and ease in use. Whichever type of frame you choose, remember that the fabric should be flat on the bed of the machine, the opposite to hand stitching.

Machine needles blunt much more quickly than hand needles, which seem to stay sharp for ever. At the start of any major machining session, fit a new needle, making sure that it is as high as possible in the needle housing and that the blunt side is at the back. A size 90 needle is suitable for medium-weight fabrics but a size 100, which is stronger, will tolerate any tendencies to jerks and hesitancy while you practise.

Starting to stitch

Place the framed fabric under the needle and lower the presser foot lever. This lever serves two functions – as well as lowering the foot, it also engages the top tension system. If you are machining with no foot, it is all too easy to forget to lower the lever. Every machine embroiderer does this from time to time and the result is a memorable tangle of threads. Turn the balance or hand wheel towards you until the needle dips into the fabric,

does give an added sense of security and confidence. Some machines have the optional extra of a plastic or 'see-through' darning foot, or an open-fronted horseshoe foot, both of which help greatly in enabling you to see where you are stitching. Set the stitch width and stitch length at '0'. Choose a firm, not too tightly woven fabric, such as calico or medium-weight cotton,

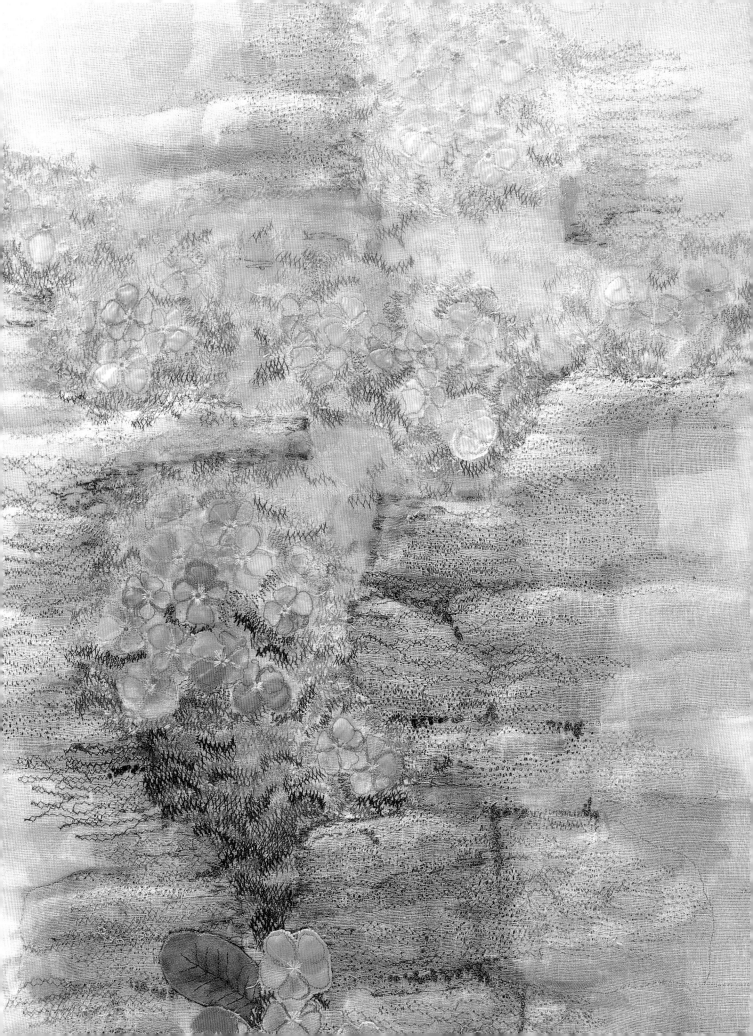

Right Tudor rose bag
Layers of organza with free
satin and straight machine
stitching
*Margaret Ross from Chris
Cooper's collection*

goes up to the highest point and just starts to come down again. At this point, the lower thread will be brought up to the surface, preventing it from being caught on the underside.

Holding the sides of the frame, start stitching at a medium speed, moving the frame quite slowly in any direction you choose. Practise short lines towards and away from you, from side to side and in curves and circles. The more relaxed you can be, the better; try not to hold your breath or hunch your shoulders. You will soon discover the effects of the balance between the speed of the machine and the speed with which you move the frame. In ordinary domestic sewing, it is usual to see each individual machine stitch, but in free embroidery a smoother line will be achieved by a very short stitch length. Moving the frame slowly and running the machine at a steady rate will give this short stitch length, not the jagged, 'dog leg' effect of individual stitches. At first beginners worry a great deal about tension, comparing their free stitching with the more familiar straight lines of machining. Small blobs or loops of the lower thread may be visible on the surface, especially on tight curves, corners and where you have hesitated for a moment. This can be seen as an early attempt at whip stitch, when the top thread is intentionally completely covered with loops of the lower thread,

giving a more raised, textured line than free stitching. These intermittent loops can be used to advantage, especially if the top and bobbin colours are different. Speckles of colour are added in, a lighter or darker shade, or perhaps a shaded or variegated thread. Whip stitch is achieved by increasing the top tension, which effectively pulls up loops of the lower thread, and by moving the frame very slowly, allowing the loops to cover the top thread. If you do not want any speckles of colour, reduce the top tension a little.

Zigzag and satin stitch

With the machine set up and the fabric framed as before, turn the stitch width lever or knob to its widest setting. Moving the frame alternately quickly and slowly, as well as varying the speed of the machine, will give either an open zigzag or close satin stitch. This patterns the fabric more quickly than running stitch and is useful for building up densely stitched, textured areas. If you work on loosely woven fabrics, such as scrim and muslin, you will achieve a delightful pulled-fabric effect.

Threads

Although you can use any machine thread for embroidery, old reels of cotton thread will not always give the best results. Machine embroidery threads are now widely available in craft shops, some department stores

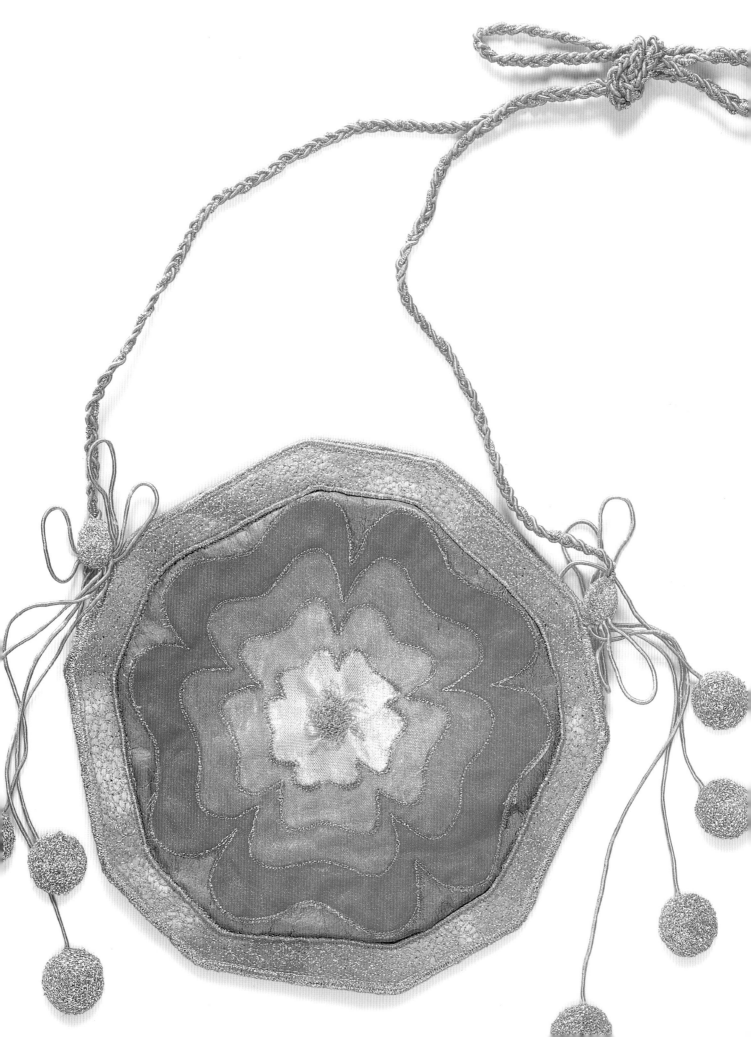

and from many of the specialist embroidery suppliers. They are usually finer, 40, 50 or even 60 denier – the higher the number, the thinner the thread. Many are rayon or acrylic, with a lovely lustre and sheen, but fine cotton is also available which gives a matt contrast to the shiny threads. There is an excellent colour range, with exciting shaded and variegated combinations. Metallic threads, again made specially for machine embroidery, are hard to resist. They are available in several shades of gold, copper, silver, colours and variegated. Particularly effective are the metallics plied with black, which are not quite as shiny.

Many embroiderers have some difficulty with the textured metallic threads we are often tempted to buy at craft days and fairs. The instructions for use on the machine are given on the shade card but, of course, you rarely have the opportunity to see or read the shade card. The recommendations are to use a larger needle than usual, size 110 (a 'jeans' needle). It is also necessary to reduce the top tension to between 1 and 2, where the numbered system is from 1 to 10, with 5 being the normal setting. With these two adjustments, textured metallic threads work well and add a new dimension to a piece of work. They are ideal for machine-wrapped cords as the delicate nature of the thread is not subjected to the normal friction of the fabric.

Above Calico printed with a grid of grated transfer crayons, overprinted with hyacinth flowers and dipped into fabric paint. Half of the piece has been machine embroidered using whip stitch with variegated threads

Right Overlapped and applied potato prints on calico with free machine stitching in shaded and metallic threads

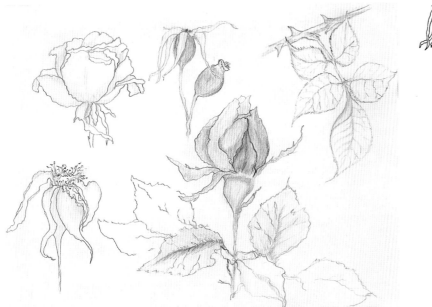

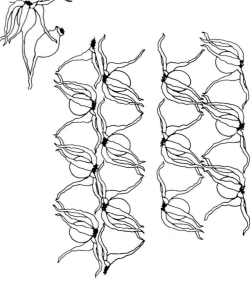

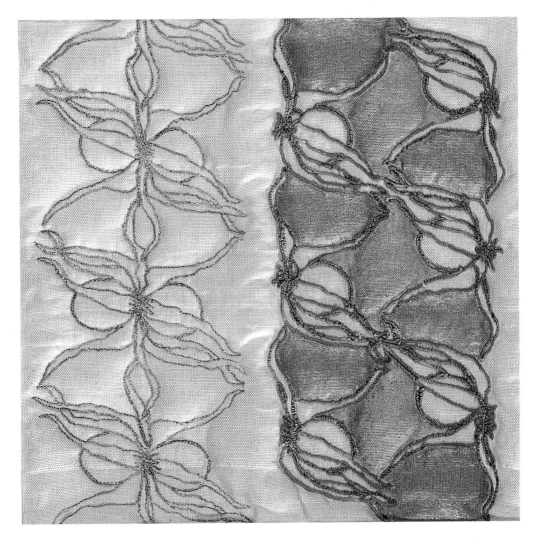

Above left Page from sketch book showing the rose in its various stages of growth

Above right Border patterns based on drawing of rose hips

Left Border patterns based on drawings of rose hips. Free machine stitching with fabric painting and metallic threads

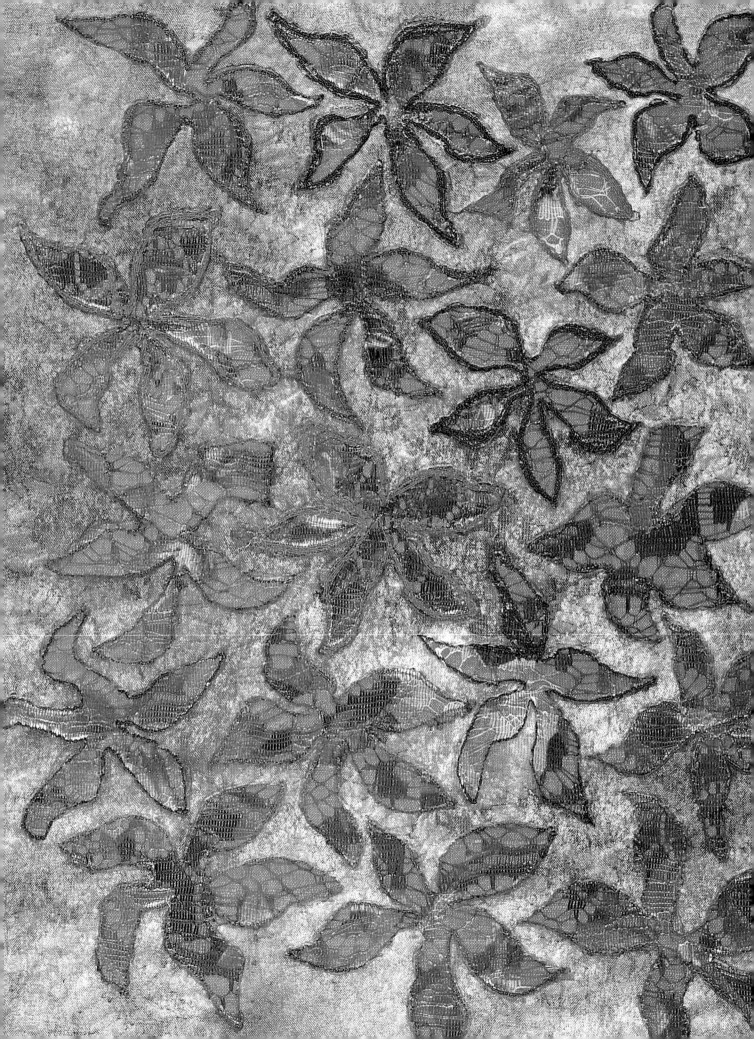

Tailor tacking foot

One of the most textural effects in machine embroidery can be achieved by using the tailor tacking foot, which is more usually associated with dressmaking techniques. There is a raised bar on the presser foot and, with the machine set for zigzag, the thread travels from side to side over the bar, resulting in a series of raised loops. With a very short stitch length (i.e. satin stitch), these loops form a textured loop-pile surface. The density can be increased further by using two threads in the needle. If you choose the colours carefully, you can create some subtle colour mixing and tonal changes. All machines can be used with two threads, even if your model does not have two spool pins. Wind two bobbins in different colours and place both on the spool pin, one on top of the other. As a precaution to stop them spinning off, put an empty cotton reel on top. Use a third bobbin for the lower thread as usual. Take the two top threads, threading the machine following the instructions in the manual for twin-needle stitching. This normally involves taking the two threads through the tension system, one at each side of the tension disc. Both threads pass through the needle together (use a needle threader if necessary). It is preferable to use fine rayon or metallic threads for this technique and a larger needle (size 100). The possible colour

Above Flower shapes worked in dense spirals using the tailor tacking foot with two threads in different colours in the needle

Left Detail of hanging based on carnations. Worked on painted felt with applied fabric painted silks and net with machine stitching
Marion Glover

Far left Layers of space-dyed silk and nets applied to dupion silk. Flowers shapes cut into the top layer of fabric with a poker pen, applied and secured with free machine stitching

permutations are endless. Try keeping one colour constant, adding a selection of different-coloured second threads in various areas of the design. Some surprising results can be achieved by mixing the primary colours of red, yellow and blue, and adding the complementary colour, a lighter or darker tint or shade or, of course, black and white. Variegated and shaded threads will add yet another colour dimension.

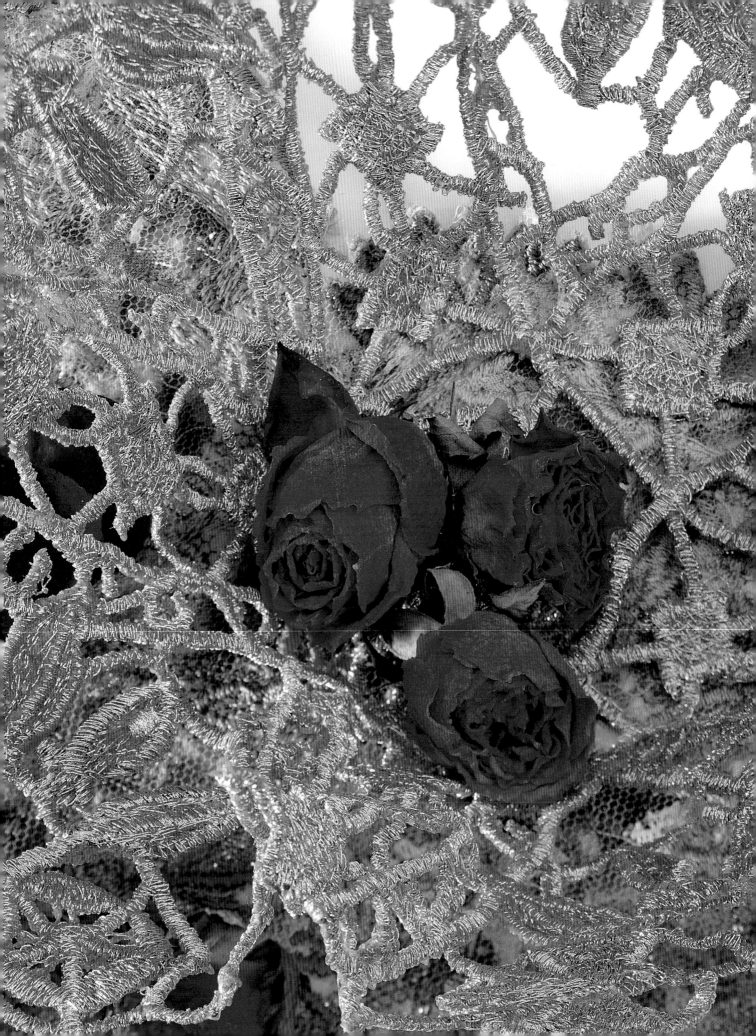

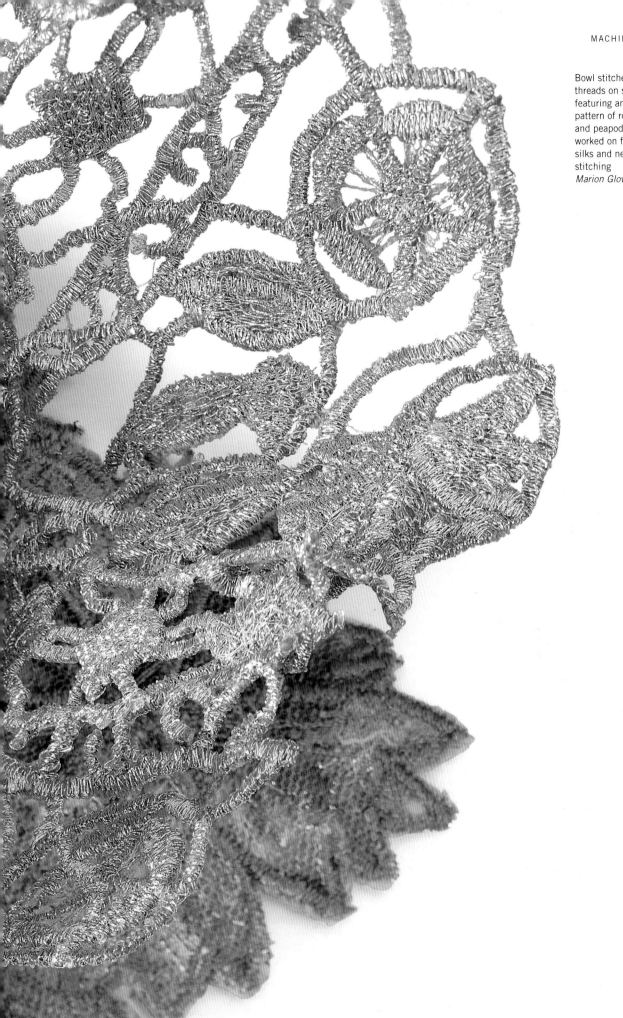

Bowl stitched with metallic
threads on soluble fabric
featuring an Elizabethan
pattern of roses, carnations
and peapods. The mat is
worked on felt with applied
silks and net and machine
stitching
Marion Glover

Previous spread Detail of hanging showing detached carnation motifs applied to a base of silk, lace and net on felt with machine stitching *Marion Glover*

Right Printed calico background with small frayed squares of fabrics, overlaid with a machine-stitched grid on vanishing muslin. Flowers of floss thread knotted onto the intersections

Grids

Grids are often seen as being very geometric and structured, having little place in the natural world of flowers. However, they have an affinity with nature in many ways, representing a backcloth of brick and stone patterns, trellis, fencing, railings, as well as the overlapping and interlacing structure of the plants themselves. Grids can be regular or irregular, wild and hairy, or delicately lacy. They offer an excellent starting point for design, giving a structure within which to arrange flowers – place them under the grid, in the spaces, on top, overlapping some of the lines or on the intersections.

Vanishing muslin grids

Interesting effects can be obtained with vanishing muslin. This is a heat-soluble fabric, rather like a stiff muslin or buckram, which disappears under the heat of an iron. Satin stitch the lines of a grid in both directions, following drawn pencil lines or freely, whichever you prefer. Stitching over pieces of firm thread or fine string will give a stronger grid. The normal method of ironing away the unwanted remaining vanishing muslin has the effect of flattening the stitching, but an alternative is to use a poker pen or soldering iron. Heat the pen and place the stitched grid on a heat-resistant surface. Draw with the hot tip of the pen along the lines and around the shapes to be cut out; you

Right Dyed silk background with fragments of silk, a machine-stitched grid and added stitching and beads

Below Wire frames wrapped with a single thread and massed machine embroidery threads

will find it burns through the heat-soluble fabric very effectively. If you work quickly, the pen will leave little hairy wisps of muslin around the stitching which can add greatly to the effect, especially if the vanishing muslin has been coloured with fabric paints before stitching. In freely-worked, irregular grids, the tip of the poker pen is ideal for burning away very small spaces. Water-soluble fabric, either the hot or cold water variety, can be used in the same way to produce grids. Remember that zigzag or satin stitch alone will tend to unravel when the fabric is dissolved away, so always add lines of straight stitching either under or on top of the zigzag.

Wire-frame grids

As an alternative to dissolving the base fabric away, grids can be made with no fabric backing at all, using a rigid wire frame to support the stitching. You can make a frame quite simply from a thin wire coat hanger. Cut off the hook with wire cutters and pull the wire into a square, covering the cut ends with sticky tape. It may not be a completely even and perfect square, but it works. With basic DIY skills, a more professional frame can be made from strong wire, a vice and a soldering iron. Wrap the frame with firm thread or fine string in both directions, choosing how regular or irregular you want the grid to be.

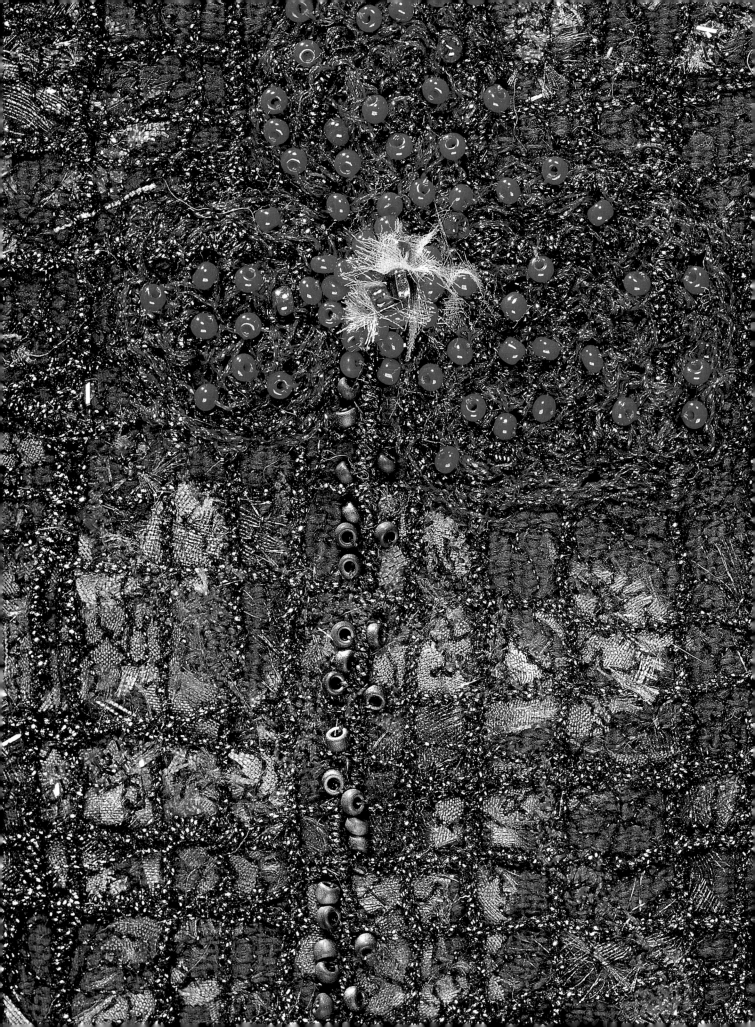

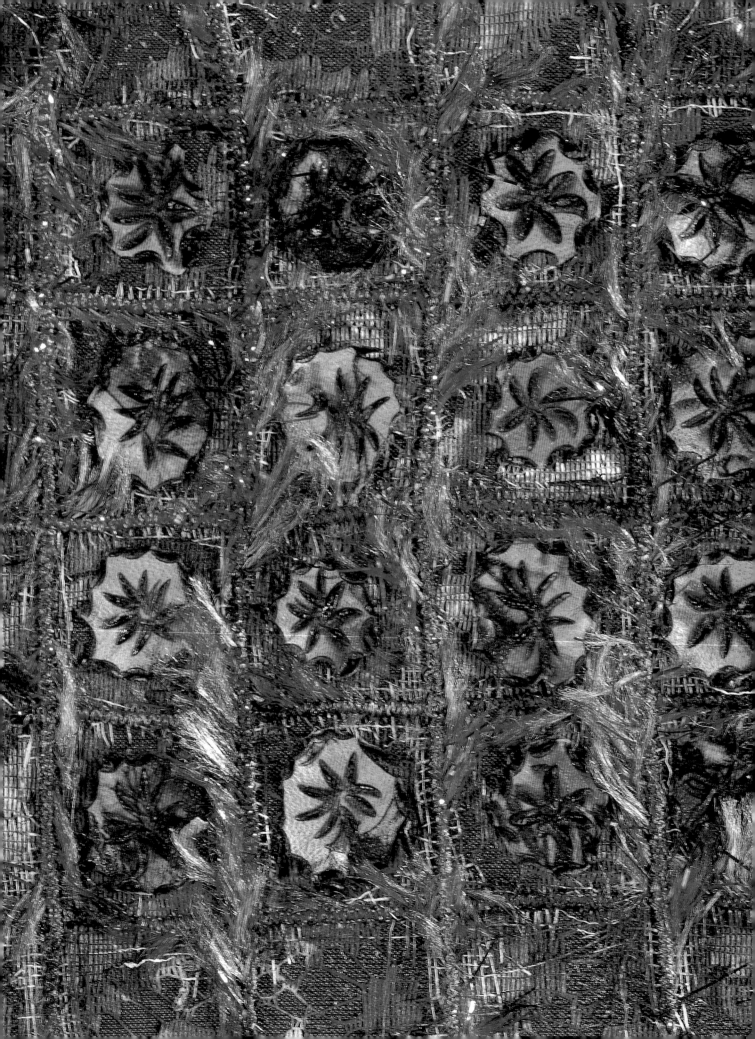

Set your machine for free zigzag and stitch over the threads until the grid is quite firm and holds together. There will be some distortion in the verticals and horizontals caused by the stitching and the absence of any fabric, but this adds to the appeal. An even more irregular grid can be made by wrapping the frame with massed fine machine embroidery threads and zigzagging quite freely over the area, catching in some of the threads and missing others as you machine up and down. This requires more stitching than you would imagine before it becomes a stable grid, or it can be left in a more lacy form.

Machining on tights

One of the advantages of machine embroidery is the ability to stitch so densely into the fabric that it becomes completely covered with thread, making a whole new surface. The more you stitch, the more distorted that surface becomes, curling and twisting beneath the mass of thread. Working small petal and flower shapes in this way gives the three-dimensional quality often needed to interpret a design.

Set your machine for free stitching as described earlier. Fit a darning foot if you have one, although you may prefer to work with no foot in place. Thread the machine with a fine rayon or metallic thread, using the same thread on the top of the machine and in the bobbin. Working on small, detached

Left Painted nets on shot silk with a machine-stitched grid on vanishing muslin, burnt out with a poker pen. Applied flower shapes of fine gloving leather burnt with the decorative tip of a poker pen

Evening bag of black velvet
and suede. The Tudor roses
are worked in dense free
machine stitching with
beaded centres and added
beaded cords and tassels

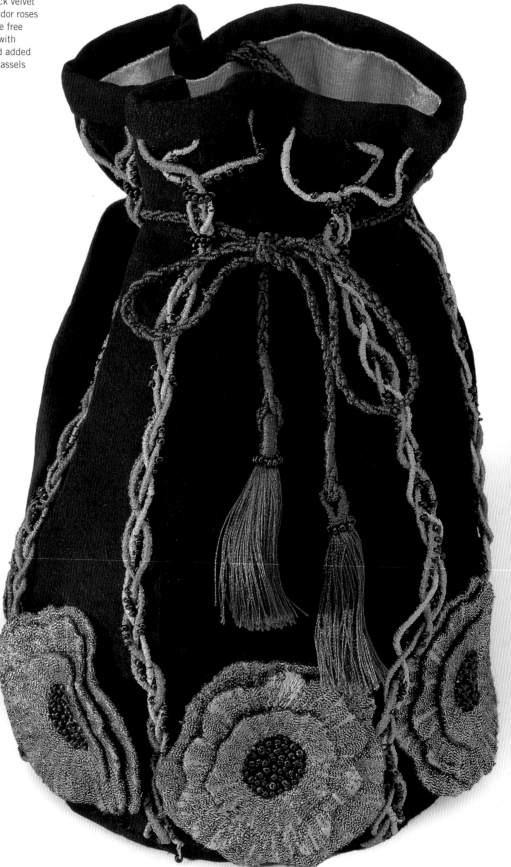

pieces of fabric can be difficult so a backing fabric is required; discarded tights (pantihose) provide the perfect answer. Slip the inner ring of a metal spring ring frame down one leg of the tights, clamping the toe end against the side of a table with your hip or leg. Pull hard at the other end of the tights, at the same time slipping the outer ring of the frame in place. This will ensure that the tights are very taut in the ring frame – preventing any subsequent problems in the stitching. Cut away the excess material from around the frame so that you are left with a single thickness to stitch on.

Prepare the fabric for the embroidery by selecting a medium-weight calico and some felt, bonding the two together with Vilene Bondaweb. Mark a flower shape onto the calico, using a hard pencil. Drawing round card templates is an easy way to do this, enabling many separate motifs to be marked on the piece of calico. Cut out each shape exactly on the pencil line. Put one of the shapes, calico side uppermost, onto the framed tights, place under the machine and lower the presser foot lever. Using running stitch, machine all over the shape, either in a spiral pattern or working from the centre outwards and back again. Stitch right to the edge of the shape and just onto the tights, covering the cut edge. Keep stitching until you can no longer see

the surface of the calico. The more you stitch, the more distorted the shape will become; with a little practice, this effect can be controlled.

An alternative to free running stitch is to use a sideways zigzag stitch for part or all of the shape. This gives a more textured, loopy effect which contrasts with areas of denser running stitch. When you have completed the stitching, remove the frame from the machine. Using a pair of sharp pointed scissors, cut the tights away from around the shape as close as possible to the stitching, still held taut in the frame. You will find that any remaining fragments of the tights disappear magically within the stitched area, leaving only the completed flower.

Fuchsia tassels

A softer, three-dimensional flower can be worked directly onto the tights, without the calico and felt required for the solid shapes just described. This gives delicate up-turned petals, reminiscent of a fuchsia, with the skirt of a tassel completing the flower. Frame the tights as before. Although the colour of the tights will not be very evident after stitching, the effect is more realistic if you use a pair which are dark red, blue or navy. Both the upper and lower machine threads will be visible in the finished flower. Choose two colours which complement each other, perhaps light and dark of the

Fuchsia tassels worked in free machining on tights in two layers with machine stitched loop-head tassels and machine wrapped cords

same colour, or a metallic thread on the spool and a colour on the bobbin.

Set your machine for free stitching. Work a four- or five-petalled flower shape, either freely or following drawn lines, leaving a small central circle unstitched. Work parallel lines round and round within each petal shape. Do not stitch densely or the petals will be too firm and stiff. When the stitching is complete, remove the frame from the machine. While it is still in the frame, cut round the flower with sharp pointed scissors as close as possible to the edge of the stitching. As you cut, the petals will start to twist and curl. Make a second flower in the same way, using the same thread colours or with slight variations. Make holes with a stiletto in the central unstitched area of each flower. Now make a little loop-headed tassel with rayon machine embroidery thread and ease the head through the central holes of both flowers. They should sit firmly around the neck of the tassel, held in place with a few hand stitches. Add a machine-wrapped cord through the loop-head of the tassel to complete your fuchsia. These would make most unusual earrings and would add a special finishing touch to many embroidery projects.

I hope you will enjoy making fuchsia tassels and that the other ideas contained in this book will inspire your own very individual interpretation of flowers in all their glory.

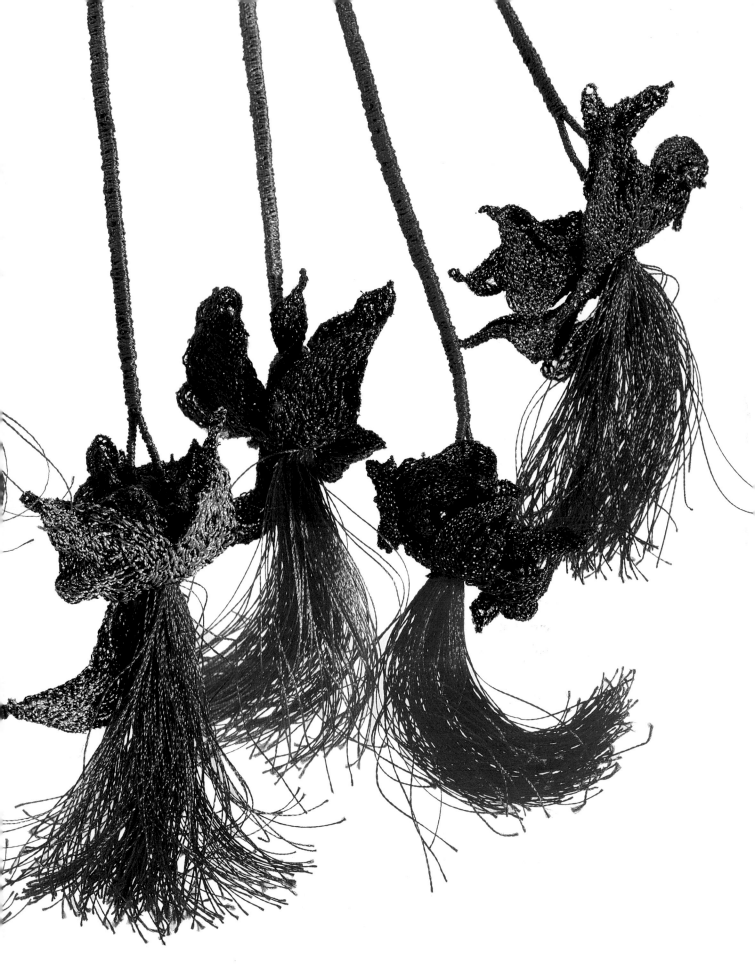

Further Reading

Some of the books in the following list may be out of print, but can hopefully be obtained from your local library or from secondhand book dealers.

Canvas Work Stitches
Mary Rhodes
B. T. Batsford Ltd

Embroidery Stitches
Anne Butler
B. T. Batsford Ltd

England is a Garden
Catherine Hamilton
Bracken Books

Fabric Painting for Embroidery
Valerie Campbell-Harding
B. T. Batsford Ltd

Machine Embroidery:
Stitch Techniques
*Valerie Campbell-Harding
and Pamela Watts*
B. T. Batsford Ltd

Embroidered Countryside
Richard Box
B. T. Batsford Ltd

Flower Gardens
Penelope Hobhouse
Frances Lincoln Ltd

Flowers for Embroidery
Richard Box
David and Charles

Planting in Patterns
Patrick Taylor
Pavilion Books Ltd

The Green Tapestry
Beth Chatto
William Collins Ltd

Machine Embroidery:
Ideas and Techniques
Pamela Watts
B. T. Batsford Ltd

Flowers and Plants in
Embroidery
Valerie Campbell-Harding
B. T. Batsford Ltd

List of Suppliers

Blue Cat Toy Company
(rubber stamps)
The Builders Yard
Silver Street
South Cerney
Gloucestershire

Borovick Fabric Ltd
16 Berwick Street
London W1V 4HP

Carolyn Warrender Stencil Designs Ltd
P.O. Box 30
Rickmansworth
Hertfordshire WD3 5LG

Madeira Threads
Thirsk Industrial Park
York Road
Thirsk
North Yorkshire YO7 3BX

McCulloch & Wallis
25-26 Dering Street
London W1R 0BH

Needle and Thread
High Street
Horsell
Woking
Surrey

Redburn Crafts
Squires Garden Centre
Halliford Road
Upper Halliford
Shepperton
Middlesex TW17 8RU

Silken Strands
33 Linksway
Gatley
Cheadle
Cheshire

The Silk Route
32 Wolseley Road
Godalming
Surrey GU7 3EA

Index